Russian
paintings and
drawings

Russian paintings and drawings

in the Ashmolean Museum

Larissa Salmina-Haskell

Ashmolean Museum Oxford
1989

British Library Cataloguing in Publication Data
Salmina-Haskell, Larissa
 Russian drawings in the Ashmolean Museum
 1. Russian Drawings. Catalogues, indexes
 I. Title
 741.947'074

 ISBN 0-907849-95-4 (case bound)
 ISBN 0-907849-96-2 (paper back)

The catalogue entries were originally published in *Oxford
Slavonic Papers,* November, 1969.
First published in illustrated book form (125 catalogue entries)
by the Ashmolean Museum, 1970.
This revised, expanded and illustrated edition, containing 146
catalogue entries, first published by the Ashmolean Museum,
in association with Oxford University Press, 1989.

Cover illustration: *Countess Musin-Pushkin,* by V.A. Serov
(1865–1911)

Designed by Cole design unit, Reading
Set in Univers
Printed and bound in Great Britain by Jolly & Barber Ltd, Rugby

Contents

Foreword

The Russian Drawings in the Ashmolean Museum by Larissa Salmina-Haskell, first published in *Oxford Slavonic Papers* in 1969, was reprinted in the following year as a separate volume with a foreword in which the Keeper, K.G. Garlick, thanked the editors of the periodical (and in particular Mr. J.S.G. Simmons) for their cooperation. The catalogue proved very successful and has been out of print for the last five years. In the meanwhile the collection has grown a little and interest in it has grown enormously and will be further stimulated by the loan exhibition to be held this winter in the Hunterian Art Gallery of Glasgow University and by the large exhibition of Russian Art to be held in the Ashmolean Museum in 1991. It is to satisfy such interest that the catalogue has been revised, with much material added to the former entries, with entries on the additions to the collection and with colour plates.

The idiosyncracies which were determined by the catalogue's original appearance in a periodical have been removed and we are grateful to Miss Emma Chambers for assistance in this task. Above all we are grateful to Mrs Haskell for the unstinting and unremunerated scholarship and care that she has lavished on these drawings over many years – and also for the attention she has given to the Talbot Collection (devoted to books, maps, prints and drawings on St. Petersburg) of which in due course another catalogue will we trust be made.

N.B. Penny
Keeper of Western Art

Introduction to the
first edition

Since 1949, as a result of three generous benefactions, the Ashmolean Museum in Oxford has assembled the richest collection of Russian art held by any public institution in this country. The foundations were laid by Mikhail Vasil'evich Braikevitch (1874–1940), who was already a well-known Russian collector and patron of the arts long before 1917. Braikevitch was born in Odessa where he later worked as a railway engineer – a profession which gave him plentiful opportunities for visits to the artistic centres of Moscow and St. Petersburg. Throughout his life collecting remained his greatest passion: 'To tell you the truth', he once wrote about himself, 'any serious collector is an egotist, not for himself, of course, but for his collection. He is insufferable and obstinate, and will stop at nothing to acquire pictures by a good painter, and among those pictures he will insist on the best.'[1]

For a short period during 1917 Braikevitch was a member of the Provisional Government and – if we may judge from the article from which we have just quoted – his position increased his possibilities of adding to his collection. By the time that he left Russia he already owned 108 pictures, and these are now in the Museum of Russian Art in Odessa.

Braikevitch's taste was formed by the 'Mir Iskusstva' ('World of Art') group, and among its painters Konstantin Somov was his favourite, followed by Alexander Benois and Leon Bakst. He admired all the best realistic artists such as Levitan and Serov (who were always appreciated by 'Mir Iskusstva' artists) but he never cared for the more *avant-garde* painters who had broken with realism and who at the time of the Revolution were rapidly assuming a dominant position in Russian art. His second collection – which is now in the Ashmolean and which was acquired mainly in Paris and London where he lived as an émigré – was built up on exactly the same principles as the first one, formed twenty years earlier; in this he was helped by the fact that many of his favourite artists were now themselves living outside Russia. His passionate determination to acquire just what he wanted is demonstrated by his success in persuading Count Musin-Pushkin to sell him Serov's portrait of his wife, and Mme Roerich to part with her famous portrait of herself by the same master. But Braikevitch now not only bought pictures but also commissioned artists to paint for him replicas of ones that he could not afford or which were out of reach in Russia. His great favourite was still Somov. In his reminiscences of the painter he recalled the early stages of their relationship: *At that time my chances of acquiring works by Somov were not good, and I owned only one picture which had been obtained for me by my friend I.I. Lazarevsky. Everything that Somov exhibited at the 'Mir Iskusstva' exhibitions was already sold before they opened. I used to go to St. Petersburg only at irregular intervals and other collectors laid their hands on everything he painted, sometimes even before they were finished.*[2]

[1] 'Pamyati K.A. Somova: lichnye vospominaniya', *Illyustrirovannaya Rossiya* (Paris), 20 May 1939, p.9.

[2] 'Pamyati K.A. Somova: lichnye vospominaniya', *Illyustrirovannaya Rossiya* (Paris), 20 May 1939, p.9.

But now, after 1924, when Somov went first to America and then settled in France, Braikevitch became his most devoted patron, so much so that many of the artist's late works were in fact painted for him: repetitions, usually, of the dreamlike world of refined eroticism which had characterized the 'perruques and crinolines' created thirty years earlier. The society for which Somov had once painted these evocations of the past had now collapsed and he seemed to be working in a void. But the support of Braikevitch enabled him to make use of reproductions of his own once famous paintings to depict yet again the 'Winter Walk' (1897), the 'Fireworks' (1904), and the 'Allée à Versailles' (1903), to which he now added two girls dressed in eighteenth-century costume.

Braikevitch gave the same kind of patronage to Alexander Benois, whose position was far stronger than that of Somov since he was still working for the theatre — replicas, for instance, of the 'Military Parade during the reign of Paul I' (1907) and of his illustration to the *Bronze Horseman*, which shows Pushkin reading the poem to his friends. But here the thirty-five-year interval has led to the evaporation of the picture's former poetry and all the dynamic power and emotion of the original have been lost in the fussy composition of the later version.

It is this kind of patronage, so exceptional in this century, which gives a special significance to the collection — it is retrospective in character, refuses to acknowledge change, and, for a Russian émigré, it must have constituted a sort of 'ivory tower' which, thanks to the eighteenth-century fantasies of Somov and the costume designs for Diaghilev, enabled him to remain in contact with a world that had now passed away.

There is evidence to suggest that Braikevitch himself considered the theatrical designs in his collection to be less important than his other drawings[3] and most Russian critics would agree with him. But the fact remains that, however evocative we find the 'retrospective' element in his bequest, the quality of the designs for the opera and ballet is so exceptionally high that we must consider these to be the glory of the collection as a whole.

Braikevitch's great sensibility and his close connections with artistic circles in Paris gave him the chance of buying a number of excellent and authentic sketches by Bakst, an artist whose early popularity led to the creation of a vast number of studio imitations and downright fakes. And from Alexander Benois he was able to obtain nine sketches for the Diaghilev production of Stravinsky's *Rossignol* (1914), which the painter himself considered to be his masterpieces, and which are indeed of outstanding quality.

A place apart in his collection is held by the four drawings of Valentin Serov. Two of these are famous portraits of women: a water-colour of Varvara Musin-Pushkin in a garden, made up of silvery grey nuances of colour, in which the sitter is depicted with warm and lively sympathy; and the far more formal one of Madame Roerich, painted some twelve years later towards the end of his career, in which the accentuated outlines and occasional gleams of bright colour turn his model into a beautiful object rather than portray a living woman. The two nude studies also belong to this later period in the artist's career, when he was increasingly interested in economizing his means of expression. The small oil sketch

[3] See letters from his daughter, Tatiana Braikevitch (Soboleva) (Ashmolean Museum archives).

by Levitan is more indicative of a desire on Braikevitch's part to have this fine artist represented in his collection than of the real significance of his contribution to Russian landscape painting.

In his will Braikevitch left his collection to '. . . some English Gallery of repute, first approaching the Tate Gallery, for their *permanent exhibition as a collection . . .'.*[4] This last condition involved grave practical difficulties, and it is for this reason that it was not until nine years later, in 1949, that sixty-eight items from the collection were at last housed in the Ashmolean Museum, where a small and constantly changing selection from it is always on display. And the same stipulation prevented the Ashmolean from accepting a number of large oil paintings (including portraits of Surikov by Serov and of Rachmaninov by Somov), which have now found a home in the Tret'yakov Gallery in Moscow and the Russian Museum in Leningrad.

Quoted from the copy in the Ashmolean Museum archives.

A second valuable collection came to the Ashmolean in 1960 from a London doctor of Russian origin, Tatiana Gourlande, whose pictures and drawings were left by her husband '. . . to a gallery in Great Britain or France as a nucleus of a Russian section or to such a one already in existence . . .'.[5] With the Braikevitch bequest in mind the executors chose the Ashmolean Museum, fortunately making no restrictive conditions. As a whole the Gourlande sketches and drawings are less important than the Braikevitch ones and could not in themselves constitute a nucleus of Russian art; but they admirably complement the already existing Braikevitch collection, adding some fine drawings by masters who were already represented and introducing others by younger members of the 'Mir Iskusstva' group who had not been patronized by Braikevitch. Of these, Tchehonine, so consistently admired in Russia for his constructivist designs on porcelain, is represented by a single but very fine water-colour portrait of his wife lying in bed with a flower on the table beside her. Two other artists whose work came to the Museum with the Gourlande bequest, are the intimately connected Alexander Jacovleff and Vasily Schouhaiev. Both graduated from the Academy of Fine Arts in St. Petersburg in the same year (1912), both were awarded gold medals and scholarships to Italy, and both often worked jointly on the same pictures. Alexander Jacovleff was personally connected with the collector and his red chalk drawing of the young Tatiana Gourlande with his own self-portrait in the background is a very fine example of his sharp, precise manner. An excellent portraitist, he unfortunately turned to landscape later in his career, and evidence that this genre was unsuited to his talents is provided by two drawings in the collection. Vasily Schouhaiev is best known for his book illustrations, but his two *Queen of Spades* drawings are somewhat mannered and do not show him at his best.

Quoted from the copy of Dr. D.T. Gourlande's will in the Ashmolean Museum archives.

Among the older generation of the 'Mir Iskusstva' group Konstantin Korovin, a close friend of Serov, earned a high reputation as a colourist and as a follower of the Impressionists. His art clearly did not appeal to Braikevitch, who owned nothing by him, whereas the Gourlande collection contains nine items, seven of them being oil sketches. These are so uneven in quality that, despite the fact that they are all signed, there might be some doubt about attributing them to Korovin himself were it not for the fact that no one was likely to forge the works of so unfashionable a

11

master. The very poor landscapes are all of Russian villages and were probably commissioned by Dr. Gourlande, but the *Corsair* and *Autumn Leaves* ballet designs (or, more likely, fantasies based on such designs) contain hints of the exuberant colours which can be seen in his earlier sets for *Don Quixote*, still used by the Kirov ballet in Leningrad. Philippe Maliavine, a contemporary and friend of Somov in the Academy, was another painter ignored by Braikevitch, but represented by one brilliant early drawing in the Gourlande bequest.

So much for the new names added in 1960. By a strange coincidence, however, notwithstanding Braikevitch's admiration for Somov, one of that master's finest designs, dating from his early and most vigorous period, also came to the Museum with the Gourlande collection, his famous costume of Columbine for Anna Pavlova, dated 1909. The two Serovs are of very much lower quality than those owned by Braikevitch, but they constitute an interesting addition to them: one is a water-colour painted when the artist was eighteen, and showing the influence on him of Mikhail Vrubel' (who painted the same model at the same time in a water-colour now in the Russian Museum in Leningrad); the other, 'Hunger', reflects Serov's early interest in social problems and illustration. Both works belonged to Serov's wife and – as is clear from labels on their original mounts – were sold by a dealer in Kiev. Another superb addition was Bilibin's portrait of Anna Pavlova in a ballet costume as a Russian princess.

Only three works in Dr. Gourlande's collection do not belong to the 'Mir Iskusstva' group: two of these are small portraits in oil, naïve but not without charm, of the owner's grandparents, by a completely un-known Russian painter of the middle of the nineteenth century named Litvinov; the other is a delicate pencil drawing which came to the Museum improbably attributed to 'Flour', and hence attracted no attention. In fact it is easy enough to recognize in this unfinished sketch the hand of the finest Russian draftsman of the first half of the nineteenth century, Pavel Fedotov. The sure and elegant line would in itself provide sufficient evidence for the attribution, but virtual confirmation exists in the form of a label on the old mount which shows that the drawing was bought from Konstantin Karlovich Flug – whose name is responsible for the mistake in attribution, and whose sister was portrayed by Fedotov in a drawing which is now in the Tret'yakov Gallery. Fedotov's drawings, like most other Russian works of the first half of the nineteenth century, are extremely rare outside his own country and this gives the Ashmolean sketch considerable interest.

The third major element to make up the collection is a group of drawings by Leonid Pasternak (1862–1945), an artist who worked at the same period as those already discussed but who holds a special place in the history of Russian painting. Like Serov, Korovin, and Levitan, Pasternak belonged to the Moscow school, and he was one of the most eminent teachers at the Moscow College of Painting, Sculpture, and Architecture, which was the centre of progressive art in Russia at the time. He started by painting genre pictures in the style of Repin, but soon gained a repu-tation as a very fine portraitist, and it was in this field that he always produced his best work. His pictures and the reminiscences of his pupils

show Pasternak to have been a man of wide culture, well acquainted with new developments in Western European art, but he always stuck firmly to the realistic convictions which he had acquired as a young student. Like most of the talented painters of his time he exhibited both with 'Peredvizhniki' ('Wanderers') and the 'Mir Iskusstva'; later he exhibited mainly with the Union of Russian Artists, of which (like Korovin, Maliavine, Serov, and Vrubel') he was a member. In 1921 his wife's ill-health brought about a move to Berlin and this exceptionally talented family was henceforward split into two parts – the sons Boris (the poet) and Alexander (the architect) continuing to live in Moscow. In 1938 Leonid and his wife left Berlin for London where they stayed while arrangements were being completed for their return to Moscow; but his wife's sudden death and the outbreak of war caused a change of plan. Pasternak and his daughters moved to Oxford; there he spent much of his time in the Ashmolean, and it is in memory of his love for this museum that in 1958 his daughters presented to it a small collection of some of his finest drawings. Through other gifts and purchases the Ashmolean now owns a total of eighteen works by Leonid Pasternak, all of them small sketches, watercolours, and drawings – apart from the large pastel portraying his two sons Alexander and Boris, which beautifully achieves his longstanding aim of combining decorative colour with psychological insight.

Finally, in 1966 Miss Mary Chamot of the Tate Gallery gave the Museum a valuable group of drawings by Larionov and Goncharova. Though they too belong to the same period of Russian art and though both worked extensively for Diaghilev – indeed Mikhail Larionov strongly influenced Diaghilev during the last years of his activity – it is no coincidence that work by them should have been presented by an English art historian rather than by a Russian collector of 'Mir Iskusstva'; for although their art is profoundly rooted in Russian sources, both of them broke decisively with the traditional school of painting which had given birth to the rival 'Peredvizhniki' and 'Mir Iskusstva' groups, whose impress is so strong in the Braikevitch and Gourlande collections.

Though much has been written about the period of Russian culture which is so well represented in the Ashmolean, it is still too recent for an objective historical assessment. But it may be worth briefly discussing some of the issues which face any student of the drawings and paintings catalogued below. In the West, for critics and public alike, the painters of 'Mir Iskusstva' have always been associated with the theatre designs produced for Diaghilev. So great was the impact of his opera and ballet companies that the costume designs for them immediately became highly fashionable collectors' pieces. Indeed nostalgia plays a preponderant part in the appreciation of this kind of art, and when a drawing by Bakst of Ida Rubinstein in the role of Saint Sebastian fetched £8,000 at Sotheby's in 1968, it was clear that this sum was paid for a highly evocative relic of a whole epoch in the history of ballet rather than for a fine example of Bakst's draftsmanship. But this aspect of the activity of the 'Mir Iskusstva' group is hardly known in Russia itself, and it is only natural therefore that their art should be very differently regarded in that country. This contrast can be illustrated by two quotations: 'It soon became apparent that Diaghilev was the obvious person to bring together these diverse person-

alities in a series of creative enterprises, first the magazine, then exhibitions, and finally the Russian ballet, the most significant expression of the World of Art movement', wrote Miss Camilla Gray in *The Great Experiment* (London, 1962), while in Russia, Natal'ya Sokolova, author of the only book devoted wholly to the movement, aimed 'to discuss mainly the paintings and to refer to the book illustrations and theatre designs only so as to indicate the size and diversity of the movement . . .'. When reading accounts of 'Mir Iskusstva' the Western reader should remember the very different evaluations of the group made in the country of its origin and abroad.

Another important feature of 'Mir Iskusstva' is that never in the history of Russian culture has an artistic movement had such eloquent sponsors. Alexandre Benois was even more distinguished as a writer and critic than as an artist, and his books and articles alone have made of him one of the most honoured figures in the Russian culture of his time. But the true significance of the movement cannot be gauged merely from the writings of its members, and it is mainly because of this reliance on the propaganda of Benois and Diaghilev that Western critics have greatly exaggerated the *avant-garde* character of 'Mir Iskusstva'. Because of the polemics of these two great advocates with the 'Peredvizhniki' and the Academy it is usually assumed that 'Mir Iskusstva' was an artistic movement all of whose principles were entirely opposed to the established canons of the day. Louis Réau is representative of this tendency:

Si nous dressons le bilan de l'activité du 'Mir Iskousstva' pendant les trente années qui se sont écoulées depuis sa fondation, il faut commencer par lui rendre cette justice qu'il a relevé dans tous les domaines, dans le domaine de l'art pur comme dans celui de l'art appliqué, le niveau de l'art russe qui était tombé très bas à l'époque des Peredvijniki... Le 'Mir Iskousstva' a eu le grand mérite de restaurer la technique que les Ambulants avaient sacrifié au sujet.[6]

[6] L. Réau, *L'Art russe de Pierre le Grand à nos jours,* ii (Paris, 1922), 235.

But in fact quite a number of the 'Mir Iskusstva' group regularly exhibited with the 'Peredvizhniki' and their journal frequently reproduced works by the latter. Behind the smoke-screen of polemics the main controversy centred on what kind of subject was most suitable for the new type of patron who was beginning to show an interest in art at the turn of the century. We can see this in the writings of one of the foremost representatives of the movement, André Levinson:

The weak spot about all this combativeness and intellectual ardour which proved fatal and unavoidable amid these divergent points of view was the lack of creative ability on the part of the group. This group had deposed and duly trampled under foot the art of the 'Wanderers' with its social tendencies and its worship of the moujik. It had done this to the greater glory of an art that is unselfish and creative. But almost immediately its members turned towards literature.[7]

[7] André Levinson, *Leon Bakst* (1923), 65.

And so it is not surprising that, while welcoming the best realistic artists, the leaders of 'Mir Iskusstva' grew increasingly hostile to the real *avant-garde* that was rapidly gaining a significant position in the artistic life of Russia. As early as 1907 – the year following the exhibition of the group

which was organized in Paris by Diaghilev – one of the leading critics of the day, Serge Makovsky, wrote:

Quite recently the painters who were grouped round 'Mir Iskusstva' seemed to be the last word in Russian painting. Their 'challenge' was arousing the stubborn hostility of a conservative public. To be with them meant to belong to the 'avant-garde'. A few years have passed and the recent innovators seem to be no longer either challenging or new. Quietly they have moved into the class of accepted veteran museum painters, and already one can hear them grumbling about the disobedient new-comers who have arrived to take their places. It is unpleasant to give up 'avant-garde' positions and sad to leave the stage of history and move back into the wings (nobody knows yet what role the future is preparing for them) but nothing can be done about it. Everyone has his turn.[8]

[8] *Zolotoe runo*, 1907, no.5, p.25.

Nor is it wholly true that the 'Mir Iskusstva' group tried to 'westernize' Russian painting in opposition to the nationalistic tendencies of 'Pered-vizhniki', even though they themselves often claimed to be doing this. Most of the 'Peredvizhniki' travelled abroad, and their pictures have much more in common with certain aspects of nineteenth-century German art than is usually acknowledged. On the other hand the cult of Versailles by Somov and Benois reflected a deeply Russian phenomenon originating in the gallicized court-life of the eighteenth century and now reappearing like some exotic but atavistic growth which was incorporated into the general nostalgia of the period.

But while rejecting *idées reçues* about 'Mir Iskusstva' we must also recognize that the group achieved for Russian painting what had already been established for Russian literature and music – recognition in the West: 'Pour la première fois depuis les origines, la Russie a *exporté* des formes d'art nouvelles et envoyé à l'étranger des artistes qui ne venaient plus en élèves, mais en initiateurs, non plus pour demander des leçons, mais pour en donner.'[9]

[9] L. Réau, loc. cit.

This may well constitute its true importance.

In the preparation of this catalogue the present author has been able to make use of the handlist covering eighty-eight of the items which was compiled by Mr. Gerald Taylor, Senior Assistant Keeper of the Museum, in 1960. This handlist not only gave details such as size and technique but also included material provided by the collectors and information about Russian ballet designs catalogued by Mr. Richard Buckle for the Diaghilev Exhibition of 1954.

The present catalogue aims to add all those items which were excluded from the handlist or which have entered the Museum since 1960, and to draw on the extensive further documentation which has now become available in Russia and elsewhere. The nature of the material necessarily makes this catalogue very different in conception from those that have been devoted to the Ashmolean Old Master drawings. Questions of attribution do not arise, but especially as regards the *émigré* painters our knowledge of the artists' lives is often very imperfect: for example, a monograph on Maliavine published in 1968 fails to give the exact date of his death, while some Western publications imply that Roerich was

alive after 1947. For this reason I have given brief biographical notes on each painter whose work is catalogued. In compiling these brief résumés of the artists' careers I have been enormously helped by the article on 'Russian painters and the stage' by Nikita Lobanov-Rostovsky[10] who, diligently searching through old periodicals and contacting the relatives of leading Russian painters, has been able to establish the chronologies of artists working for the theatre in Western Europe and America. It is due to Mr. Lobanov-Rostovsky's kindness that I was able to see this very important article before it became generally accessible.

[10] In *Transactions of the Association of Russian-American Scholars in the U.S.A.*, ii (N.Y., 1968), 131–210.

It would hardly have been possible for me to have completed this catalogue without the most generous help from M. Serge Ernst, the greatest authority on this period of Russian art and the author of fundamental monographs on Serov, Somov, Benois, and Roerich as well as innumerable articles. These contributions to the subject constitute not only the prime source for all researchers in the field, but are also written in a style whose elegance makes them a joy to read.

The staff of the Russian Museum in Leningrad, and in particular of its Department of Paintings and Drawings, kindly made available to me material in their possession relating to the relevant works in the Ashmolean. Above all, I must thank Professor A.N. Savinov of the Repin Institute in Leningrad who, with extraordinary generosity, gave me full access to his notes from the Somov archives which refer to this artist's works in the Braikevitch collection. It is thanks to him that extracts from these are now published here for the first time.

Leonid Pasternak's daughters, Mrs. Josephine Pasternak and Mrs. Lydia Pasternak-Slater, have given me every help in cataloguing their father's drawings in the Museum and have shown me some unpublished materials regarding them. Mrs. Braikevitch has kindly answered my questions concerning her late husband's bequest and has supplied me with additional information of great use. My father-in-law, Arnold Haskell, has given me the benefit of his vast knowledge of the Russian ballet.

I am most grateful to the Department of Western Art in the Ashmolean Museum, whose staff have been consistently helpful, friendly, and sympathetic. And I would like to end with a word of special thanks to Mr. John Simmons, the General Editor of *Oxford Slavonic Papers*, in which journal this catalogue has appeared; for he suggested that a description of the Ashmolean's Russian collections would be more than welcome and has subsequently given me help and encouragement which have far exceeded anything that even the most demanding author has the right to hope for.

My husband has helped me at every stage in the preparation of this catalogue and it is to him that I wish it to be dedicated.

Larissa Salmina-Haskell
1969

Introduction to the revised edition

Larissa Salmina-Haskell

The addition to the collection (and thus to the catalogue) of 21 Russian pictures, drawings and watercolours during the last 19 years may not seem remarkable, but in fact the change in the character of the collection of Russian art in the Ashmolean Museum has been much more significant than these numbers may suggest. Since the appearance of the original version of this catalogue (first in the *Oxford Slavonic Papers* and then as a separate book) the collection has become much wider known and the Ashmolean has received a bequest of unique importance – a large collection of prints mostly related to St. Petersburg which will be catalogued as a separate unit although it also contains some watercolours by Russian artists. Of these I have decided to include only one in the present catalogue *A View of the Peter and Paul Fortress in St. Petersburg* by Alexandre Benois because its exceptional artistic quality is such that it makes a significant contribution to the group of Benois's drawings which were already in the collection.[1] Two more watercolours by Benois – a gift from Lady Charlotte Bonham-Carter – constitute an invaluable addition to the corpus of his theatrical work. One is a costume design for Stravinsky's ballet *Petrushka* and the other is a sumptuous project for the décor of *Diane de Poitiers* for Ida Rubinstein – both of them theatrical occasions not previously represented in the collection. A fine costume drawing by Bakst – an early design for the famous ballet *Thamar* – came to the Ashmolean as a bequest. It was in the first personal exhibition of Bakst held at the Fine Art Society in London in 1911 and made a valuable addition to the choice selection of Bakst's early designs in the museum. But the most remarkable Bakst drawing – the study of a nude – was bought from the Fine Art Society. This famous drawing of 1910 is quintessential for the expression of sensuality in Bakst's art. It is worth noting that only two more drawings came to the museum through acquisition during these last 16 years, but both of them represent additions of a very high quality to the collections. One is a theatrical design by Constantin Korovine, and another a charming and delicate watercolour by Chekhonine who is famous above all for his avant-garde designs for porcelain. Formerly there was only one drawing by the latter in the collection.

An important event for the Russian collection in the years since the first edition of this catalogue was the centenary exhibition of Mstislav Dobuzhinsky held in the Ashmolean in 1975 through the generosity and persistant energy of the artist's son Rostislav who not only lent works which belong to the family but who also compiled and published the catalogue of the exhibition. As a result of this exhibition three more works by Dobuzhinsky were added to the existing collection. A large oil landscape was presented by Rostislav Dobuzhinsky as an example of his father's work not hitherto represented in the museum – it would certainly make a notable impact in any room devoted to the Russian collection.

[1] Since this introduction was written one small drawing by Dobuzhinsky was found amongst Talbot's private papers. As Talbot evidently did not regard it as part of his collection, it was decided to add it to Dobuzhinsky's entries in this catalogue.

17

And two other designs by Dobuzhinsky for the ballet *Coppelia,* given by the artist's son to the curators, were anonymously presented by them to the collection. The centenary exhibition of Dobuzhinsky held in the Tretiakov Gallery in Moscow in 1975 brought to light much useful comparative material.

Two paintings in oil by Constantin Somov were donated to the museum by the Braikevitch family thus adding important works to the already existing nucleus of his oeuvre; and in 1969 the centenary exhibition of his work held at the Russian Museum in Leningrad, provided a mass of new information concerning the Somovs in the Ashmolean as it included drawings from Braikevitch's collection which are now in the Museum of Russian Art in Odessa.

But the most considerable changes in the catalogue have been occasioned by the publication of Somov's archive. Throughout his life Somov kept a diary which not only provides a day by day record of all his artistic activity but also gives invaluable information about the cultural life of his time: exhibitions, ballet and concerts. He writes beautifully with short and precise sentences revealing a sharp original mind in his characterisation of both people and events. And after 1924, when he left Russia with the exhibition of Russian art for America, and thereafter settled in Paris, he wrote regularly to his sister in Leningrad and these detailed letters not only supply material for his biography but are also an important source for artistic life in Paris in the 20s and 30s. After Somov's death his papers came into the possession of Braikevitch and when he died and his collection was already in the Ashmolean his family decided to deposit Somov's archive in the Russian Museum in Leningrad. When I was working on the first edition of the catalogue these archives were in the process of being transcribed and studied (Somov's handwriting was difficult) and Prof. Savinov who was working on it gave me his unpublished notes of the passages in the letters and diaries relevant to the drawings in the Ashmolean. Soon afterwards Prof. Savinov died and two curators of the Russian Museum in Leningrad – Julia Podkopaeva and Anna Sveshnikova – edited the archive for publication. The result was a thick volume which combined extracts from the diaries and letters (unfortunately omitting any references to Somov's personal life) with the memoirs of his contemporaries, following the example of the similar volume *Aleksandr Benua razmishl'iaet* . . . edited by I. Silberstein and A. Savinov which came out in 1969.

This publication has allowed me to correct certain mistakes which had crept into the list of the Braikevitch collection and which were therefore included in the first edition of this catalogue. The collection of Leonid Pasternak's pictures and drawings in the Ashmolean has been enriched by only one item – an early sketch of 1900 of Boris Pasternak as a boy with his nanny – presented by Sir Karl Parker, but the intervening years have been important for studies of his work because several major exhibitions have been held both in Russia and in this country, and as the Ashmolean collection is the most important publicly owned depository of his work after the Tretiakov Gallery in Moscow and the Russian Museum in Leningrad, loans from the museum were essential for Pasternak's exhibitions in Scotland, Oxford and London.

Three artists – Dmitri Bouchène, Simon Lissim – make their first appearance in this edition of the catalogue with a small group of their drawings donated by the artists themselves, while one by Alexandra Exter (also hitherto unrepresented) was given by her executor Simon Lissim. And the steady flow of new catalogues and publications which have accompanied the growing interest in Russian art in general has also led to some changes and additions.

I am particularly grateful to Emma Chambers for all her invaluable help.

Introductory note

Arrangement
Order is alphabetical by artist's names (Figures in parentheses indicate the number of works by the artist concerned): Bakst (13), Benois (18), Bilibin (3), Bushen (2), Dobuzhinsky (9), Exter (1), Fedotov (1), Goncharova (6), Jacovleff (3), Korovin (12), Larionov (4), Levitan (1), Lissim (2), Litvinov (2), Maliavine (1), Pasternak (18), Roerich (3), Rom (2), Schouhaiev (2), Serov (6), Somov (33), Tchehonine (2), Tchelitchev (2).

Dates
Dates before 1918 are given in both Old and New Style, e.g. 1 (13) January 1878, wherever possible. A single pre-1918 date indicates that it has not proved possible to determine whether our source is in Old or New Style.

Dimensions
Measurements are in millimetres, verticals first.

Provenances
Works from the Braikevitch Collection were acquired by bequest in 1949; Chamot Collection drawings were presented by Miss Mary Chamot in 1966; material from the Tatiana Gourlande Collection came by bequest from Dr. D.T. Gourlande in 1960; and those from the Pasternak/Pasternak-Slater Collection were presented in 1958 by the artist's daughters, Mrs. Josephine Pasternak and Mrs. Lydia Pasternak-Slater – unless otherwise indicated. Two drawings from Mr Gwenoch Talbot's Collection came, together with his bequest, in 1973–4.

Transliteration
In cases in which a traditional or personally favoured Western form of spelling for a Russian surname exists, e.g. Jacovleff (for Yakovlev), this has been adopted. Otherwise British Standard 2979:1958 (with final 'y' in personal names) has been used. Exception to these conventions include titles of books or the artists' own preferred spelling, e.g. **K.A. Somov** – See pp.79–94 Somoff, Somof, Somov.

Léon Bakst

Born (Lev Samoilovich Rosenberg) Grodno,
10 May 1866; died Paris, 28 December 1924.
An outstanding Russian painter who worked as a
portraitist, book illustrator, and – above all – as a
theatrical designer, in which field he won an
international reputation. Exiled from St. Petersburg
in 1909 as a Jew without a residence permit, he
thereafter lived mainly in Paris, where his major
theatrical work was done for Diaghilev and Ida
Rubinstein.

1 *Half-length portrait of Andrey Bely*

Signed: L. Bakst. Black and red chalk on light-
brown paper, white chalk on background and blue
and green on the costume. 458 x 340.

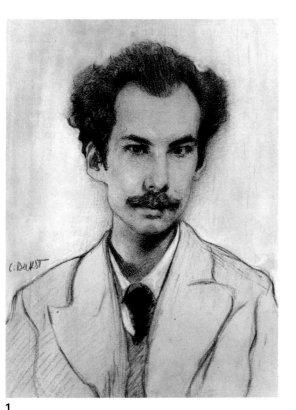

1

In the middle of the first decade of the century a
Moscow patron and art collector Nikolay
Riabushinsky commissioned a number of famous
poets to be drawn by equally famous artists. The
intention was to reproduce them in his art journal
Zolotoe Runo (*Le Toison d'Or*). Bakst was
entrusted with several portraits among them one of
Andrey Bely who was then at the height of his
fame as a Symbolist and who recorded the
occasion, in characteristically extravagant style in
his memoires: 'Red haired, red faced, well balanced
and intelligent – Bakst would not portray me in an
ordinary way – he needed me to be raised to a pitch
of ecstasy so that he could pin this ecstasy like a
butterfly to my image: for this purpose he used to
bring from the 'World of Art' the crafty Walter
Nuvel, whose hobby was to excite his partners by
discussing problems of art in the same way as a
surgeon touches with a scalpel an open wound.
Ghippius was also brought in for the same purpose.
As a result I was excited to such a degree that my
tooth started throbbing. I would grimace like an
orang-outang, nursing my cheek and this
bloodthirsty tiger Bakst with his burning green eyes
would fix this with his brush. After each sitting
I would have the impression that Bakst had broken
my jaw, and it came out like this in the portrait. My
shame (according to Bakst – a masterpiece) later
was exhibited at the 'World of Art' exhibition and
Sergey Jablonovsky from *Russkoe Slovo*
exclaimed: 'it is enough to see the portrait to
understand what kind of poet is Andrey Bely!' The
portrait was screaming of my decadence – just as
well it disappeared into thin air. A second more
widely reproduced version proclaimed that I was a
man with a moustache rather a neurasthenic . . .'
(Andrey Bely, *Between Two Revolutions*, 1934,
p.67). The Ashmolean drawing is a close replica of
this portrait – a replica recorded by Bely. The
original is now in the Moscow Literary Museum.
It is dated 1905 and in 1906 it was included in
Diaghilev's 'Exposition de L'Art Russe' at the Salon

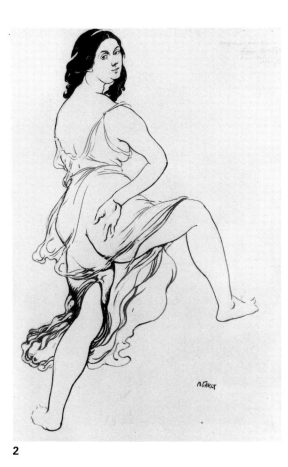

2

d'Automne in Paris. The second version of the portrait mentioned by Bely was reproduced in the January number of *Toison d'Or* of 1907 facing p.72.

Coll.: M.V. Braikevitch. **Exhib.**: Fine Art Society, London, 1912 (No.90); Fine Art Society, London, 1927 (No.83); Ashmolean, 1950 (No.5); Fine Art Society, London, 1973 (No.114); Fine Art Society, London, 1976 (No.88). **Lit.**: J.E. Bowlt *World of Art* Russian Literature triquarterly, Ann Arbour, 1971, p.189; C. Spencer, *Leon Bakst*, 1973, p.225.

2 *Portrait of Isadora Duncan dancing*

Signed: 'Л. Бакст' and inscribed in pencil in upper right-hand corner: 'ширина клише — три столбца Бирж. Въдомостей'; signed again: 'Л. Бакстъ'. Brush and indian ink over traces of pencil. Corrected in Chinese white. 489 × 333.

Isadora Duncan left a vivid description of meeting Léon Bakst in St. Petersburg: 'At supper in the house of Pavlova which was more modest than Kshessinskaya Palace but equally beautiful,' she wrote 'I sat between the painters Bakst and Benois, and met, for the first time, Serge Diaghileff, with whom I engaged in ardent discussion on the art of the dance as I conceived it, as against Ballet. That evening, at supper, the painter Bakst made a little sketch of me which now appears in his book, showing my most serious countenance, with curls sentimentally hanging down one side' (Isadora Duncan, *My Life,* 1928, p.177). As always is the case with her memoirs she avoids any dates (it was not until 1976 that her real birth date was discovered – 26 May 1877 – when her birth certificate was found in San Francisco), but the drawing by Bakst which she mentions, and which is now in the collection of Moscow's art historian Ilya Silberstein (housed in the newly opened Museum of Private Collections in Moscow), is dated 1908, so that the supper in Pavlova's house took place during her second visit to Russia (she travelled to St. Petersburg for the first time in 1903). The book she mentions is in fact V. Svetlow, *Le Ballet Contemporain,* 1912, with the portrait drawing reproduced in facsimile between pp.60–61, but it was also printed as a postcard at the same time. Arnold Haskell illustrated it in his *Diaghileff: his Artistic and Private Life,* facing p.186 in the edition of 1935 and p.126 of the edition of 1955. It was used by Bakst for the face of his full length portrait drawing (whose expressive pose is on the borderline of caricature) now in the Ashmolean which he did for the St. Petersburg paper *Birzhevye vedomosti (Stock Exchange News)* 12 December 1907.

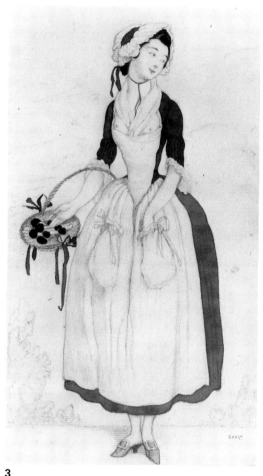

3

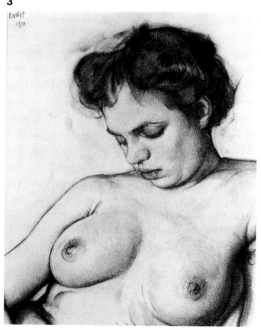

4

Coll.: M.V. Braikevitch. **Exhib.:** Ashmolean, 1950
(No.5); 'Mir Iskusstva', Walker's Galleries, London,
1950 (No.15); 'Diaghilev'. Edinburgh, 1954
(No.456, p.38, repr.) and London, 1955 (No.456,
repr.); Fine Art Society, London, 1973 (No.116);
Fine Art Society, London, 1976 (No.89). **Lit.:**
R. Buckle, *In Search of Diaghilev*, 1955, p.13
(repr.); A. Haskell, *Ballet Russe*, 1968, p.39 (repr.);
C. Spencer, *Leon Bakst*, 1973, pp.229 and 235
(repr.); I. Pruzhan, *Lev Samoilovitch Bakst*, 1975,
p.95, (in Russian); I. Pruzhan, *Leon Bakst*, 1987,
(repr. pl.155).

3 *Design for a costume of Subrette*

Signed: 'Bakst'. Black chalk and watercolour.
295×165.

The drawing is not dated but J.N. Pruzhan believes
it to have been done in 1909, which seems to me in
accordance with the style of the drawing.

Coll.: M.V. Braikevitch. **Exhib.:** Ashmolean, 1950
(No.9); 'Mir Iskusstva', Walker's Galleries,
London, 1950 (No.14). **Lit.:** J.N. Pruzhan, *Lev
Samoilovich Bakst*, 1975, p.104 (repr.)

4 *Study of a nude (half-length)*

Signed and dated: 'Bakst 1910'. Charcoal.
306×255.

This study from a model was later used in Bakst's
erotic *Yellow Sultana* of 1916 (see A. Levinson,
Leon Bakst, 1922, Pl.XXXV).

Purchased in 1976. **Exhib.:** Fine Art Society,
London, 1973–4 (No.127). **Lit.:** *Unedited
Works of Bakst.* Essays on Bakst by Louis Réau,
Denis Roche, V. Svietlov and A. Tessier, 1927,
(repr. opp. p.20).

5 *Design for Mme Kuznetsova's costume in act
III of Thamar*

Signed, dated, and inscribed: 'Bakst 1910. Thaïs
Mme Kousnétzow III acte'. Pencil and
watercolours. 277×207.

Also shown in colour on p.97.

Maria Nikolaevna Kuznetsova-Benois (born 1880)
was a famous soprano at the Mariinsky Opera in
St. Petersburg. She made her début there in 1905
and sang a leading role in the first production of
Rimsky-Korsakov's *Grad Kitezh* in 1907; from 1910
she often sang at the Paris Opera, where Thaïs in

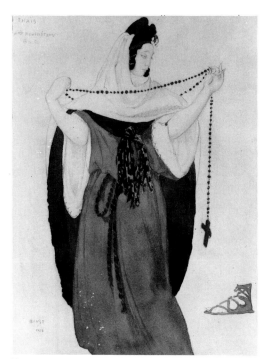

5

6

the Massenet opera became one of her outstanding roles.

She married Massenet's nephew as her second husband (her first husband was the nephew of Alexandre Benois). Bakst who was a friend, and who showed great admiration for her, suggested her for the role of Potiphar's wife in the *Legend of Joseph* and also collaborated with her on several occasions.

Coll.: M.V. Braikevitch. **Exhib.:** Ashmolean, 1950 (No.1); 'Mir Iskusstva', Walker's Galleries, London, 1950 (No.16); 'Russian Art and Life', Hove Museum of Art, 1961, (No.178); The Fine Art Society, London, 1973–4 (No.9). **Lit.:** A. Levinson, *Leon Bakst,* 1922, p.157; J.N. Pruzhan, *Lev Samoilivitch Bakst,* 1975, p.142 (repr.) and p.218; J.N. Pruzhan *Leon Bakst,* 1987, (repr. pl.15).

6 *Costume of 'La Divinité Mineure' for Narcisse*

Signed and dated: 'Bakst 1911'; inscribed: 'Divinité mineur "Narcisse"'. Pencil and watercolours. 339 x 200.

The ballet *Narcisse* with music by Tcherepnine was first peformed by the Diaghilev Company at Monte Carlo on 26 April 1911 with Nijinsky in the title role and Karsavina as Echo. Their costumes were sold at Sotheby's on 13 June 1967 (lots 63–4). Bakst was responsible for the libretto as well as for the décor and costumes.

Coll.: M.V. Braikevitch. **Exhib.:** 'Exhibition of Drawings by Leon Bakst with a prefatory note by Huntley Carter, Fine Art Society, London, 1912 (No.1); Ashmolean, 1950 (No.2); 'Diaghilev', Edinburgh, 1954 (No.77) and London, 1955 (No.77). **Lit.:** A. Levinson, *Leon Bakst,* 1922, p.45 (repr.).

7 *Design for a costume in* St. Sebastien

Signed: 'Bakst'; inscribed: 'St. Sebastien "6 victimaires" 2 acte, velours'. Watercolours with gold over soft pencil. 314 x 223.

Also shown in colour on p.97.

D'Annunzio's *St. Sebastien* with music by Debussy, choreography by Fokine, and décor and costumes by Bakst, was first performed at the Théâtre du Châtelet in Paris on 21 May 1911.

Coll.: M.V. Braikevitch. **Exhib.:** Ashmolean, 1950 (No.7); Hatton Gallery, Newcastle, 1978; The Fine Art Society, London, 1973–4, (No.22).

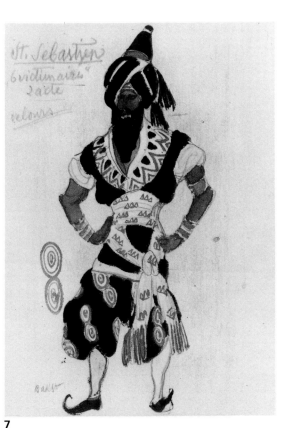

7

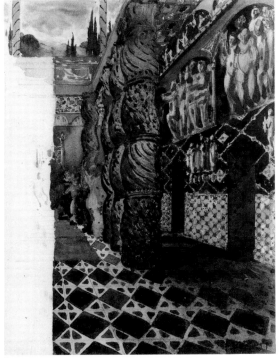

8

8 *Sketch for the Imperial Palace in* St. Sebastien

Signed: 'Bakst'. Watercolours. 375 x 295.

Also shown in colour on p.101.

A finished version of the same décor is reproduced in A. Levinson. *Leon Bakst,* 1922, p.71.

Coll.: M.V. Braikevitch. **Exhib.**: Fine Art Society, London, 1912 (No.98); Fine Art Society, London, 1927 (No.83); Fine Art Society, London, 1973–4, (No.16). **Lit.**: A. Alexandre, *The Art of Leon Bakst,* 1913, pl.47.

9 *Costume design for Lesguines in* Thamar

Signed and dated: 'Bakst 1912'. Watercolours and silver. 197 x 112.

The ballet *Thamar,* inspired by Lermontov's poem, with music by Balakirev, was, in a great measure, Bakst's creation. It was first performed in Théâtre du Châtelet in Paris, 20 May 1912. Another drawing with similar costume design was shown in the Fine Arts Society Exhibition in London in 1976 (No.39).

Bequeathed by Miss J. Shaw in 1976.

10 *Design for Pollux's costume in* Hélène de Sparte

Signed: 'Bakst'; inscribed: 'Hélène de Sparte' costume de Pollux Premier costume, NB! Deux lances si le jeu le permet! Cuirasse unie sans plaquettes. Motif d'ornement' [beneath the shield] 'mat! maillot selon la teinte.' Pencil and watercolours. 280 x 208.

The lyrical drama *Hélène de Sparte*, adapted by D. de Séverac from Verhaeren, was first performed in Paris at the Théâtre du Châtelet on 4 May 1912 with Ida Rubinstein in the lead. For Pollux's costume Bakst used one of his own earlier drawings (see *Zolotoe runo*, 1906, No.4, p.18: 'Chef dans (Œdipe à Colone'). Three costume drawings by Bakst for *Hélène de Sparte* were sold at Sotheby's on 18 July 1968 (lots 22–3, 28). The design for the décor of Act III is in the Musée des Arts Décoratifs in Paris.

A prototype of our drawing based on the ancient greek vase painting served for the production of Sophocles' play *Oedipus at Colonna* at the Imperial Alexandrinsky Theatre, St. Petersburg in 1903. (Sotheby's, 14 November, 1988, lot 138). Four

9

10

costume designs for the same production from the collection of Prince A. Schervachidze, one of which (lot 27) repeats the same prototype, were sold on 6 June 1979 at Sotheby's.

Coll.: M.V. Braikevitch. **Exhib.**: 'Leon Bakst', Fine Art Society, London, 1912 (No.56); Ashmolean, 1950 (No.8); Fine Art Society, London, 1976 (No.34). **Lit.**: J.N. Pruzhan, *Lev Samoilovich Bakst,* 1975, p.219; J.N. Pruzhan, *Leon Bakst,* 1987, pl.57 (repr. in colour).

11 *Décor for* La Tragédie de Salomé

Signed and dated: 'Bakst, 191[?]'. Watercolours and bodycolours. 459x625.

Also shown in colour on p.101.

The subject of Oscar Wilde's play *Salomé* presented a great attraction for the new symbolist vogue in the theatre and ballet at the beginning of the twentieth century. The earliest designs for *Salomé* by Bakst were created in 1908 with Ida Rubinstein, a famous society beauty and a dancer, in the title role. With music by Glazunov, it was directed by Alexandre Sanin and performed at the Théâtre de Châtelet in Paris in 1912. A year later Bakst was designing costumes and décor for another famous interpreter of *Salome* – Loie Fuller. That musical drama based on Robert d'Humière's poem with the title *La Tragédie de Salome,* with music by Florent Schmitt and choreography of Boris Romanov was first shown in the Théâtre des Champs-Elysées on 13 June 1913.

Coll.: M.V. Braikevitch. **Exhib.**: Ashmolean, 1950 (No.3); Fine Art Society, London, 1973 (No.5); Hatton Gallery, Newcastle, 1978. **Lit.**: A. Levinson, *Leon Bakst,* 1922, p.59 (repr.); C. Spencer, *Leon Bakst,* 1973, p.235, pl.127 on p.140; J.N. Pruzhan, *Lev Samoilovich Bakst,* 1975, p.219; J.N. Pruzhan, *Leon Bakst,* 1987, pl.53 (repr. in colour).

12 *Portrait of Virginia Zucchi*

Signed and dated: 'Bakst 1917'. Inscribed: 'Questo ritratto è stato disegnato sopra me stessa dal Signor Bhakst a Parigi il 27 November 1917 Umile Virginia Zucchi' [inscription now separately mounted]. Pencil. 329x233.

Virginia Zucchi was a famous prima-ballerina in the Imperial Theatre in St. Petersburg. The great dramatic force of her interpretation produced a strong impact on young Diaghilev and all the circle of the future 'World of Art' and through them had a definite influence on the development of Russian

11

Bakst
1917

12

art (see A. Haskell, *Ballet Russe*, 1968, p.40). Valerian Svetlow has left us an eye-witness description of the circumstances under which this drawing was made: 'One day I received the following letter from Bakst: "Please, do not fail to come this afternoon at 3 p.m.; there is a surprise in store for you." I found in his studio an old lady of 70 or more, sitting as model for him, while he was drawing with a pencil. She was rather short, grey-haired, with lively dark eyes. I wondered why he invited me and what was the promised "surprise". "Do you not recognise her?" – asked Bakst slyly looking at me through his eye-glasses. Some far-away, distant and dim image strove, as it were, to rise on my memory's surface, but in vain. "I am Virginia Zucchi" – said the old lady, laughing. Yes this was a surprise for me indeed! Zucchi, the delight of St. Petersburg, Zucchi, to whom were dedicated the enthusiastic articles of K. Skalkovsky, who found that her "shoulders possessed more real poetry than the Italian literature taken as a whole". Yes it was she. I told her that in my "Ballet Museum" there was preserved one of her shoes presented by her to Skalkovsky, and which he bequeathed with the rest of his collections, to me. On the inner side of the shoe Zucchi wrote, in Italian: "In these shoes are to be found those 'pointes' which pierced your heart." We began to remember St. Petersburg, its lovers of ballets, the Empress Maria Theatre. . . . By this time, Bakst was ready with her portrait and begged her to sign it. As to Mme Zucchi, she had to leave the same night for Nizza where she was staying with her daughter. Later on I had the great satisfaction to see this portrait at Bakst's posthumous exhibition.' (Louis Réau, Denis Roche, V. Svietlov and A. Tessier, *Essays on Bakst*, 1927, p.121).

Coll.: M.V. Braikevitch. **Exhib.:** Ashmolean, 1950, (No.4); 'Diaghilev' Edinburgh, 1954 (No.525) and London, 1955 (No.542); 'Russian Art and Life', Hove, 1961 (No.147); Fine Art Society, London, 1973 (No.115). **Lit.:** R. Buckle, *In Search of Diaghilev*, 1955, p.13 (repr.); J.N. Pruzhan, *Lev Samoilovich Bakst*, 1975, p.194 (repr.); J. Pruzhan, *Leon Bakst*, 1987, pl.178 (repr.).

13 *Design for the Count's costume in Act III of The Sleeping Princess*

Signed and dated: 'Bakst 1922'. Watercolours with gold and silver. 287 x 197.

Also shown in colour on p.98.

The Sleeping Princess, with music by Tchaikovsky was first produced by the Diaghilev Ballet on 2 November 1921 at the Alhambra Theatre in London. Bakst created a sumptuous décor and

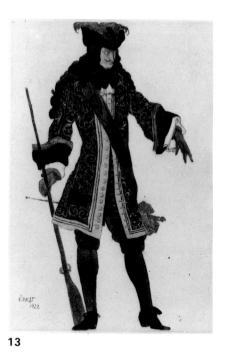

13

costumes to match, but the extremely expensive production was financially disastrous and costumes and décor were seized by Oswald Stoll.

Bakst did not get paid and he never again worked for Diaghilev. Rather surprisingly many costume drawings for this production bear the same date as our drawing '1922' which is a year after the production took place. Were they post-dated on purpose to avoid sequestration? The problem remains unsolved, though it should be noted that Sir Karl Parker suggests that "the drawing was made specially" for reproduction in A. Levinson's *Designs of Leon Bakst for The Sleeping Princess* of 1923. A replica of our drawing was sold at Sotheby's on 4 November 1982 (Lot 17).

Purchased in 1957. **Exhib.**: Hatton Gallery, Newcastle, 1978; 'Diaghilev', Sainsbury Centre, Norwich, 1979–80. **Lit.**: A. Levinson, *The Designs of Leon Bakst for The Sleeping Princess*, 1923, pl.XXVIII; K.T. Parker in *Annual Report of the Visitors of the Ashmolean Museum*, 1957, p.63; J.N. Pruzhan, *Lev Samoilovitch Bakst*, 1975, p.220.

Aleksandr Nikolaevich Benois (Benua)

Born St. Petersburg, 21 April (3 May) 1870; died Paris, 9 February 1960. Founder and leading member of the 'Mir Iskusstva' group, his greatest achievements in the arts were in book illustration and stage design. He was a brilliant art historian and an outstandingly important figure in Russian culture of the first quarter of the century. He moved to Paris in 1927 and thereafter worked chiefly as a stage designer.

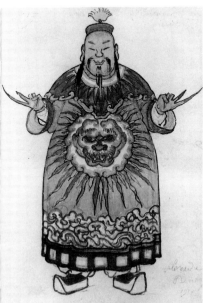

14

14 *Design for the Emperor's costume in* Le Rossignol

Signed, dated, and inscribed: 'Alexandre Benois, 1914, n.19. L'Empereur à son réveil'. Watercolours and bodycolour over black chalk. 470 x 330.

This and the following eight items form part of Benois' designs for the Diaghilev production of Stravinsky's opera *Le Rossignol,* performed at the Paris Opera in 1914. Later, in 1920, Diaghilev adapted the music for a ballet with choreography by Massine and décor and costumes by Henri Matisse. Benois considered that his sets were one of his triumphs and never forgave Diaghilev for commissioning new ones from Matisse. The Matisse designs show to a certain extent the influence of the earlier Benois production (cf., for example, the Matisse drawing sold at Sotheby's on 18 July 1968 (lot 139)).

The Russian Museum at Leningrad owns six drawings by Benois for the same production (from the artist's collection).

Coll.: M.V. Braikevitch. **Exhib.:** Ashmolean, 1950 (No.17); 'Diaghilev', Edinburgh, 1954 (No.51) and London, 1955 (No.62); '50 Years of Ballet Designs', Indianapolis, John Herron Museum, 1959 (No.100); Hartford, Wadsworth Atheneum, 1959 (id.); San Francisco, The California Palace of the Legion of Honor, 1959 (id.); New York, The American Federation of Arts, 1960 (id.); 'Stravinsky and the Dance', New York, Wildenstein and Co., 1962 (No.5); 'Les Ballets Russes de Serge de Diaghilev', Strasbourg, 1969 (No.285). **Lit.:** S. Ernst, *Aleksandr Benua,* 1921 (repr. facing p.56).

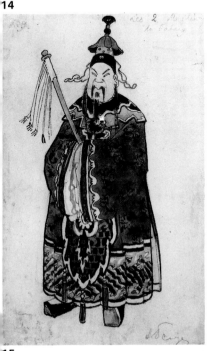

15

15 *Design for the costume of the two palace marshals in* Le Rossignol

Signed twice and inscribed: 'Alexandre Benois A Бенуа n. 9. Les 2 Marechaux du Palais'. Bodycolours and silver over red and purple chalks. 462 × 295.

See comments under No.14.

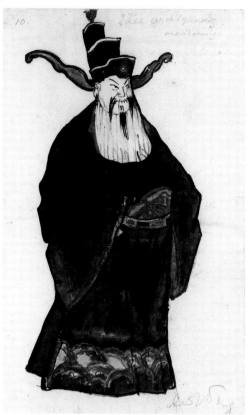

16

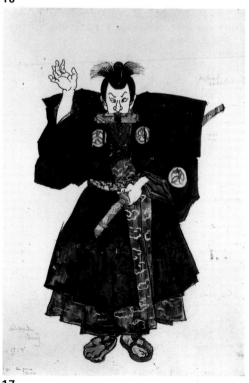

17

Coll.: M.V. Braikevitch. **Exhib.:** Ashmolean, 1950 (No.11); 'Diaghilev', Edinburgh, 1954 (No.54) and London, 1955 (No.64); '50 Years of Ballet Designs', Indianapolis, John Herron Museum, 1959 (No.94); Hartford, Wadsworth Atheneum, 1959 (id.); San Francisco, The California Palace of the Legion of Honor, 1959 (id.); New York, The American Federation of Arts, 1960 (id.); 'Stravinsky and the Dance', New York, Wildenstein and Co., 1962; 'Diaghilev', Strasbourg, 1969 (No.287). **Lit.:** M.N. Pjarskaya, *The Russian Seasons in Paris 1908–1929.* 1988, pl. 121 (repr. – mistakenly as a costume of Emperor).

16 *Design for the costume of the chief mandarins in* Le Rossignol

Signed and inscribed: 'Александр Бенуа n. 10, Les 2 archigrands mandarins'. Bodycolours, indian ink, and gold and silver paint over black chalk. 468 × 289.

See comments under No.14.

Coll.: M.V. Braikevitch. **Exhib.:** Ashmolean, 1950 (No.16); 'Diaghilev', Edinburgh 1954 (No.58) and London, 1955 (No.66); '50 Years of Ballet Designs', Indianapolis, John Herron Museum, 1959 (No.99); Hartford, Wadsworth Atheneum, 1959 (id.); San Francisco, The California Palace of the Legion of Honor, 1959 (id.); New York, The American Federation of Arts, 1960 (id.); 'Stravinsky and the Dance', New York, Wildenstein and Co., 1962; 'Diaghilev', Strasbourg, 1969 (No.286); Henrie-Unslad Foundation, Norway, 1971.

17 *Design for Monsieur Ernst's costume in* Le Rossignol

Signed dated, and inscribed: 'Alexandre Benois, 1914. Monsieur Ernst: d'après Kunioshi, рис. n. 30'. Bodycolours and indian ink over pencil. 490 × 323.

See comments under No.14.

Coll.: M.V. Braikevitch. **Exhib.:** Ashmolean 1950 (No.13); 'Diaghilev', Edinburgh, 1954 (No.55) and London, 1955 (No.61); '50 Years of Ballet Designs', Indianapolis, John Herron Museum, 1959 (No.96, 97, or 98); San Francisco, The California Palace of the Legion of Honor, 1959 (id.); New York, The American Federation of Arts, 1960 (id.); 'Diaghilev', Strasbourg, 1969 (No.290).

18 *Design for the costume of a dancer brandishing a sword in* Le Rossignol

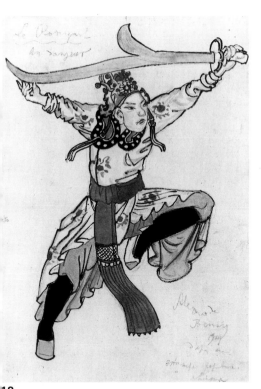

18

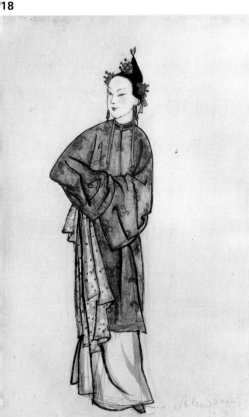

19

Signed, dated and inscribed: 'Alexandre Benois
1914 d'après une estampe populaire chinoise.
Le Rossignol. Un danseur'. Bodycolours and
watercolours over black and green chalks.
433 x 296.

See comments under No.14.

Coll.: M.V. Braikevitch. **Exhib.:** Ashmolean, 1950
(No.12); 'Diaghilev', Edinburgh, 1954 (No.53) and
London, 1955 (No.61); '50 Years of Ballet
Designs', Indianapolis, John Herron Museum,
1959 (No.95); Hartford, Wadsworth Atheneum,
1959 (id.); San Francisco, The California Palace of
the Legion of Honor, 1959 (id.); New York, The
American Federation of Arts, 1960 (id.);
'Diaghilev', Strasbourg, 1969 (No.292).

19 *Design for Mademoiselle Briand's costume
in* Le Rossignol

Signed, dated, and inscribed: 'Alexandre Benois
1914 Mlle Briand. La petite chinoise'.
Watercolours, white, and indian ink over pencil.
492 x 307.

See comments under No.14.

Coll.: M.V. Braikevitch. **Exhib.:** Ashmolean, 1950
(No.14); 'Diaghilev', Edinburgh, 1954 (No.59)
and London, 1955 (No.63); '50 Years of Ballet
Designs', Indianapolis, John Herron Museum,
1959 (No.96, 97, or 98); Hartford, Wadsworth
Atheneum, 1959 (id.); San Francisco, The
California Palace of the Legion of Honor, 1959
(id.); New York, The American Federation of Arts,
1960 (id.); 'Diaghilev', Strasbourg, 1969 (No.291);
Henrie-Unslad Foundation, Norway, 1971.

20 *Design for a costume in* Le Rossignol.
(On verso) *Preliminary sketch for a man's
costume*

Signed, dated, and inscribed: 'Alexandre Benois
1914 Le Rossignol Mlle [?]'. Colours and
inscription affected by damp. Watercolours and
gold paint over brown and orange chalk.
Verso: brown chalk. 467 x 279.

See comments under No.14.

Coll.: M.V. Braikevitch. **Exhib.:** Ashmolean, 1950
(No.15); '50 Years of Ballet Designs', Indianapolis,
John Herron Museum, 1959 (No.96, 97, or 98);
Hartford, Wadsworth Atheneum, 1959 (id.); San
Francisco, The California Palace of the Legion of
Honor, 1959 (id.); New York, The American
Federation of Arts, 1960 (id.)

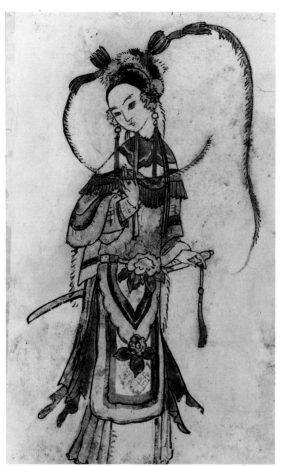

20

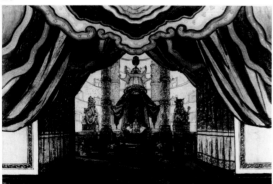

21

21 *Design for the décor of the Emperor's bedroom in* Le Rossignol

Signed, dated, and inscribed: 'Alexandre Benois 1914–1917 . . . Moscou-St. Petersburg-Paris'. Bodycolours. 630 x 970.

Also shown in colour on p.102.

A replica of this design from the artist's collection is now in the Russian Museum in Leningrad. Another sketch for the same décor (from a private collection in Paris) is reproduced in S. Ernst's *Aleksandr Benua,* 1921, facing p.54.

See also comments under No.14.

Coll.: M.V. Braikevitch. **Exhib.:** Ashmolean, 1950 (No.18); 'Diaghilev', Edinburgh, 1954 (No.49) and London, 1955 (No.59; repr. p.15); '50 Years of Ballet Designs', Indianapolis, John Herron Museum, 1959; Hartford, Wadsworth Atheneum, 1959 (id.); San Francisco, The California Palace of the Legion of Honor, 1959 (id.); New York, The American Federation of Arts, 1960 (id.); 'Stravinsky and the Dance', New York, Wildenstein and Co., 1962. **Lit.:** *Harper's Bazaar,* Aug. 1954, p.31 (col. repr.); A. Haskell, *Ballet Russe,* p.66 (repr.).

22 *Design for the décor of 'La Salle du Trône' in* Le Rossignol (Act II)

Signed and dated: 'Alexandre Benois 1914'. Bodycolours. 1010 x 1090.

Also shown in colour on p.102.

There is a replica in the Russian Museum in Leningrad and another version (dated 1917) is reproduced in A. Benois, *Reminiscences of the Russian Ballet,* 1941, facing p.364.

See also comments under No.14.

Coll.; M.V. Braikevitch. **Exhib.:** Exhibition of Russian Art, London, June-July 1935 (No.762); Ashmolean Museum, 1950 (No.19); 'Diaghilev', Edinburgh, 1954 (No.54) and London, 1955 (No.60; repr. p.15); '50 Years of Ballet Designs', Indianapolis, John Herron Museum, 1959; Hartford, Wadsworth Atheneum, 1959 (id.); San Francisco, The California Palace of the Legion of Honor, 1959 (id.); New York, The American Federation of Arts, 1960 (id.); 'Stravinsky and the Dance', New York, Wildenstein and Co., 1962. **Lit.:** S. Ernst, *Aleksandr Benua,* 1921 (repr. facing p.54 – perhaps a replica); **Lit:** M.N. Pojarskaya, *The Russian Seasons in Paris 1908–1929,* 1988, (repr. pl.118).

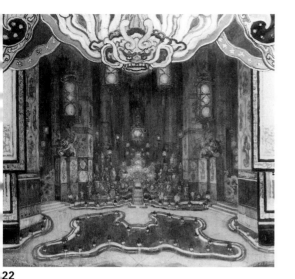

22

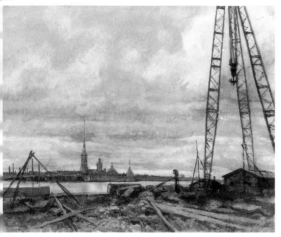

23

23 *A view of the Peter and Paul Fortress across the River Neva in St. Petersburg*

Signed, dated, and inscribed: 'Alexandre Benois, St. Petersbourg 1922'. Watercolours. 475 x 600.

Also shown in colour on p.108.

The view is taken from the windows of the Hermitage Museum in Leningrad where Alexandre Benois was at the time in charge of Paintings. It records the reconstruction being carried out on the embankment.

Coll.: Gweneth Talbot.

24 *Costume of Russian sleigh-driver for Stravinsky's ballet* Petrushka

Dated and inscribed by the artist: 'Petrouchka 1925 pour Copenhagen N 25' and on verso: 'Petrouchka. Cocher de Cour. N 12.' Watercolours. 305 x 230.

Coll.: Lady Charlotte Bonham-Carter. Presented by her in 1972.

25 *Design for the backcloth of* L'Impératrice aux rochers

Signed and dated: 'Alexandre Benois 1925'. Bodycolours with gold and silver over pencil. 487 x 641.

Also shown in colour on p.103.

L'Impératrice aux rochers by Saint-Georges de Bouhélier with music by Honegger was first performed on 12 February 1927 at the Paris Opera by Ida Rubinstein's company. Fouquet's 'Livre d'Heures d'Étienne Chevalier' provided the inspiration for Benois' décor. An almost identical version is illustrated between pp.352 and 353 of *Aleksandr Benua razmyshlyaet,* ed. I.S. Zil'bershtein [and] A.N. Savinov, 1968.

Coll.: M.V. Braikevitch. **Exhib.:** Ashmolean, 1950 (No.20). **Lit.:** A. Benois, *Memoirs,* ii, 1964. p.258.

26 *Design for the coronation robes of the Empress Catherine II*

Signed with a monogram: 'A B', and inscribed: 'No. 7. Catherine II. ''Ornat'' de Couronnement. La Grande couronne impériale toute en diamants et perle. Cheveux naturels *non* poudrés. Péctoral en diamants: Corsage et jupe sur immenses paniers en gros satin. La jupe brodée d'aigles impériales en

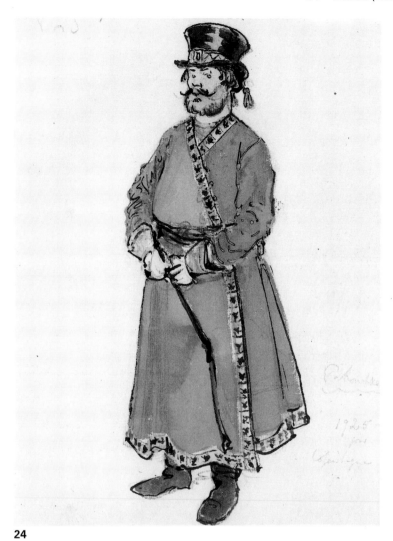

24

25

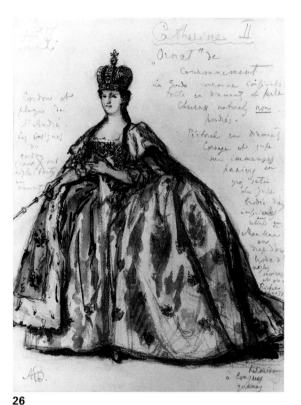

26

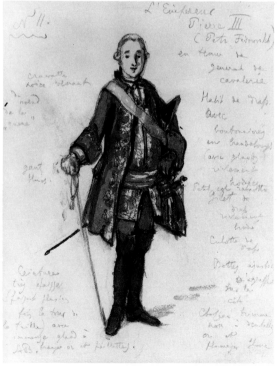

27

relief en or. Manteau du drap d'or brodé d'aigles noires et or. Riche épaisse hermine à longues queues. Cordon et plaque de St. André. Les insignes du cordon (croix sur aigle) toutes en diamants. 'Watercolours over black chalk, corrected in red chalk. 313 x 234.

This and the following drawing were made for Alexander Korda's film *Catherine the Great* in 1934. Serge Ernst reports that Benois based his design on his favourite portrait of Catherine II in her coronation robes by Lampi.

Coll.: M.V. Braikevitch. **Exhib.:** Ashmolean, 1950 (No.21); 'Russian Art and Life', Hove, 1961 (No.148).

27 *Design for the costume of the Emperor Peter III*

Signed with a monogram: 'A, B', and inscribed: 'N 11 L'Empereur Pierre III (Petr Fedorovitch) en tenue de general de cavalerie. Habit de drap. Avec boutonnières en brandebourgs (avec glands) richement brodées. Petit col rabattu. Gilet de drap richement brodé. Culotte de drap. Bottes ajustées d'agraffes sur la côté. Chapeau tricorne noir à dentelles or et plumage blanc. Cravatte noire venant de nœud de la ''queue''. Gants blancs. Ceinture très épaisse (faisant plusieurs fois le tour de la taille) avec immense gland à franges or et paillettes.' Watercolours over black and red chalks. 309 x 238.

See comment under No.26.

Coll.: M.V. Braikevitch. **Exhib.:** Ashmolean, 1950 (No.21).

28 *Décor for* Diane de Poitiers

Signed and dated: 'Alexandre Benois 1934'. Inscribed: 'Diane de Poitiers.' Verso: 'Alexandre Benois ''Diane de Poitiers.'' Act I. (pour Mme Rubinstein) Opera de Paris. 1934. N. 32. Pen, indian ink, watercolours and bodycolours. 382 x 630.

The ballet *Diane de Poitiers* with music by Ravel was performed at the Grand Opera, Paris in 1934 by Ida Rubinstein's company.

Coll.: Lady Charlotte Bonham-Carter. Presented by her in 1972.

29 *The 'Cascades d'or' at Peterhof*

Signed and inscribed: 'Alexandre Benois.

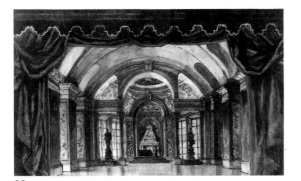

28

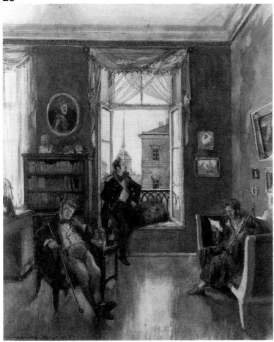

29

Peterhof. Les cascades d'or'. Watercolours and bodycolours heightened with white. 425×475.

Throughout his life Benois continued to paint views of Peterhof (now Petrodvorets). The best known is the series of lithographs after his own watercolours which date from 1918. The 'Cascades d'or' belongs to the series of watercolours 'The Fountains at Peterhof' which Benois painted in Paris in 1936 (see his *Memoirs* ii, 1964, p.261).

Coll.: M.V. Braikevitch. **Exhib.:** Ashmolean, 1950 (No.23); 'Russian Art and Life', Hove, 1961 (No.115). **Lit.:** M. Etkind, *Aleksandr Nikolaevich Benua*, 1965, p.196. Moscow, 1965), 196.

30 *'White Nights'*

Signed and dated: 'Alexandre Benois 1939'. Watercolours. 480×405.

This watercolour is based on the famous Benois illustration to Pushkin's poem 'The Bronze Horseman', first published in *Mir iskusstva*, 1904, No.1, p.9. It shows Pushkin reading his poem to his friends. Exhibition catalogues suggest quite improbable identifications for these, e.g. Del'vig and Zhukovsky. Serge Ernst and other Russian art-historians consider that the figure of the man smoking a pipe is intended for Vyazemsky. The drawing was commissioned by Braikevitch.

Coll.: M.V. Braikevitch. **Exhib.:** Ashmolean, 1950 (No.25); 'Mir Iskusstva', 1950 (No.12); 'Russian Art and Life', Hove, 1961 (No.112). **Lit.:** M. Etkind, *Benua*, 1965, p.196 (where the dimensions are given incorrectly as '16×19cm.', i.e. the inch-size figures have been applied to centimetres).

31 *Military parade during the reign of Paul I (c.1801)*

Signed, dated, and inscribed: 'Alexandre Benois, Paris, 1939'. Bodycolours. 480×625.

Also shown in colour on p.107.

From 1907 onwards Benois worked on a series of pictures on themes from Russian history which were commissioned from him by the Moscow publisher I. Knebel. Reproductions of the pictures were to be hung in schools. The above subject was the first in the series and shows the Emperor Paul in front of the recently completed St. Michael 'Castle' – in which he was soon to be murdered. He watches the marching soldiers and sends officers who make mistakes straight to Siberia. The original picture is now in the Russian Museum in Leningrad

and is reproduced in colour facing p.120 of Etkind's
Benua, 1965, and also as pl.112 in the album *State
Russian Museum: Paintings and Sculpture*, 1968.
The size of the Leningrad picture is 396 x 825mm.
The Ashmolean version was made thirty-two years
later for Braikevitch, and there are slight differences
between it and the earlier one – the most noticeable
being the avoidance of similarity in the shapes of
the noses of the Emperor and of the officer whom
he is scolding. A sketch for No.31 is in the
collection of Serge Ernst in Paris.

Coll.: M.V. Braikevitch. **Exhib.**: Ashmolean, 1950
(No.24); 'Mir Iskusstva', 1950 (No.13). **Lit.**: M.
Etkind, *Benua*, 1965, p.196.

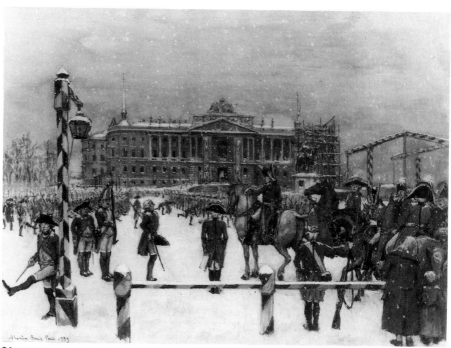

Ivan Yakovlevich Bilibin

Born near St. Petersburg, 4(16), August 1876; died in Leningrad during the siege, 7 February 1942. Studied at the St. Petersburg Academy of Fine Arts under Repin. Member of the 'Mir Iskusstva' group. His main interests lay in book illustration and stage design, on the latter of which he embarked in 1907. He lived in England and France from 1908 until 1936 when he returned to the Soviet Union, becoming Professor of Theatre Design at the Leningrad Academy of Fine Arts.

32 *Design for the costume of a Russian fairy-tale princess*

Signed with a monogram and dated: '[Pyramid between two palm-trees] И. Б. 1923'. Watercolours and bodycolours with gold and silver over pencil. 355 × 265.

Also shown in colour on p.99.

Designed for Anna Pavlova in the one-act ballet 'Old Russian Folklore' on the theme of Pushkin's poem 'Skazka o tsare Saltane' with music by Nikolay Tcherepnine and choreography by Novikoff. It was first performed at Covent Garden in London on 17 September 1923. A Bilibin design for another costume for Pavlova in the same ballet was sold at Sotheby's on 18 July 1968 (lot 147). Both drawings portray the features of the ballerina. Photographs of Pavlova dancing in Bilibin's costume are reproduced in John and Roberta Lazzarini, *Anna Pavlova*, 1980, pp.104–105.

Coll.: Dr. Tatiana Gourlande. **Exhib.:** 'Anna Pavlova', London Museum, 1956 (No 69; repr. pl.16).

33 *Design for the costume of 'Babarikha' (the Matchmaker) in Rimsky-Korsakov's opera* Tsar' Saltan

Signed with a monogram, dated, and inscribed: 'Бабариха И Б 1928 J. B.'. Watercolours and bodycolours with silver paint. 430 × 287.

Also shown in colour on p.99.

This and No.34 were made by Bilibin for the 'Opéra privé de Paris' (under the direction of Marie Kuznetsova) for their Théâtre des Champs-Elysées productions in 1929.

Bilibin designed décor and costumes of *Tsar Saltan* with the participation of Tschekhotichina-Potozkaya, but *Grad Kitezh* was produced in Korovin's décor. *Tsar Saltan* and *Grad Kitezh* were produced by Evreinov, Mel'nikov, and

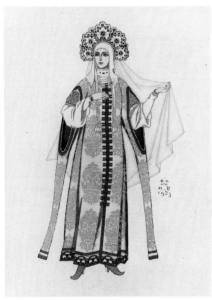

32

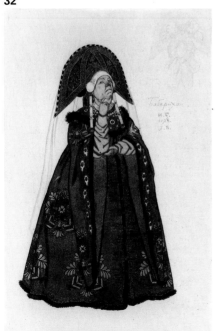

33

Sanin with Chaliapine as the principal singer. In 1934 the production of Rimsky-Korsakov's *Grad Kitezh* with the décor by Bilibin was staged in Brno. (G.V. Golinez and S.V. Golinez, *Ivan Yakovlevich Bilibin*, 1972, p.164).

Coll.: M.V. Braikevitch.

34 *Design for the décor of* Grad Kitezh

Signed and dated: 'И. Б. 1928. J. Bilibine'. Watercolours with silver and gold paint over pencil. 414 × 492.

Also shown in colour on p.104.

See comments under No.33.

Coll.: M.V. Braikevitch. **Exhib.:** 'Russian Art and Life', Hove 1961 (No.182). Hatton Gallery, Newcastle, 1978.

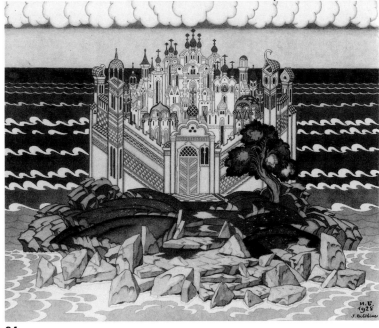

Dmitrii Dmitrievich Bushen
(Dimitri Bouchène)

Born 26 April (8 May) 1893 St. Tropez; lives in Paris. Bouchène was born into a Russian family of French Huguenot extraction. He studied in the School for the Encouragement of the Arts in St. Petersburg and was closely associated with the Mir Iskusstva movement. In 1925 he emigrated to Paris and since then he has worked mostly as a theatre designer.

35

35 *Design for Act 1 of Gounod's* Faust

Signed Bouchène. Inscribed on verso: 'Bouchène. "Faust". Amsterdam'. Gouache and acrylic paint. 580 x 787.

The Production of Gounod's Faust with Bouchène's décor was realised in the Opera House at Amsterdam in 1955 (see N. Lobanov *Dmitri Dmitrievich Bouchène* in *Transactions of the Association of Russian-American Scholars in U.S.A.*, 1982).

Coll.: Mrs Pauline B. Taylor. Presented by her in 1972.

36

36 *Design for the ballet* Le Nozze di Aurora

Signed: 'Bouchène'. Gouache and acrylic paint. 525 x 750.

The ballet *Le Nozze di Aurora* based on the finale of Tchaikovsky's *Sleeping Princess* with Bouchène's décor was produced at the Scala, Milan in 1956 (see N. Lobanov, op. cit.).

Coll.: Mrs Pauline B. Taylor. Presented by her 1972.

Sergey Vasil'evich Chekhonin *see* nos.143–4.

Pavel Fedorovich Chelishchev *see* nos.145–6.

Mstislav Valerianovich Dobuzhinsky (Dobujinsky)

Born Novgorod, 2 (14) August 1875; died New York, 20 November 1957. Studied at the Aschbe Art School in Munich and later in St. Petersburg. One of the active members of the 'Mir Iskusstva' group, he began designing for the theatre in 1907. He became a Professor in the Academy of Fine Arts in Petrograd in 1922, emigrating four years later and working thereafter for a number of European and American theatres.

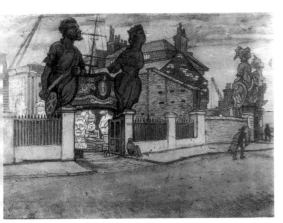

37

37 *Old Wharf in London*

Signed dated, and inscribed: 'M. Добужинский Лондонъ 15 іюля 1906 г.'. Black chalk and bodycolours, heightened with white; on straw-coloured paper. 282 × 380.

Coll.: P.M. Ustimovich; M.V. Braikevitch. **Exhib.:** Ashmolean, 1950 (No.28). **Lit.:** E. Gollerbakh, *Risunki M. Dobuzhinskogo*, 1923, II, p.84 (repr.).

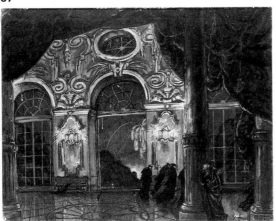

38

38 *Design for a set for the opera* La Dame de Pique

Signed with a monogram and dated: 'MD 1925'; inscribed on verso: 'M. Добужинский Пиковая дама. Балъ. Августъ 1925'. Bodycolours and indian ink. 496 × 645.

Also shown in colour on p.104.

La Dame de Pique by Tchaikovsky with décor and costumes by Dobujinsky was staged by A. Olek and A.M. Jilinsky at Kaunass in 1934. Some other designs for this performance, which are now in the Theatre Museum in Vilnus (Catalogue of Dobujinsky's Centenary Exhibition, Tretiakov Gallery, Moscow, 1975, Nos. 401–404) bear the same date as the Ashmolean design – 1925 – which leads us to believe that most of the designs were created by Dobujinsky in 1925 and used for the production of 1934.

Coll.: M.V. Braikevitch. **Exhib.:** Ashmolean, 1950 (No.30); 'Dobujinsky', Ashmolean, 1975 (No.21).

39 *Design for a set for the opera* Eugène Onegin

Signed and dated: 'M. Dobujinsky, 1935'. Bodycolours and indian ink. 312 x 412.

Also shown in colour on p.103.

This design was for the production by B.F. Daughevetis of Tchaikovsky's *Eugeny Onegin* at Kaunas in 1935. Other designs for the same

production are in the Theatre Museum in Vilnus
and were shown in the Centenary exhibition of
Dobujinsky in the Tretiakov Gallery in Moscow in
1975 (Nos. 419, 420–22).

Coll.: M.V. Braikevitch. **Exhib.:** Ashmolean, 1950
(No.31); 'Mir Iskusstva', 1950 (No.20);
'Dobujinsky', Ashmolean, 1975 (No.30).

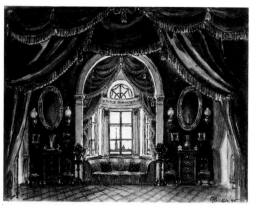

39

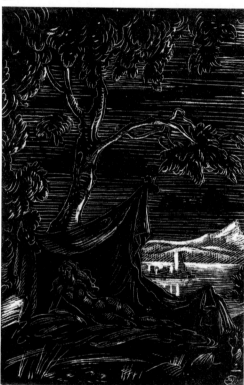

40

40 *Drawing for an unidentified book illustration*

Signed with a monogram: 'M D'. Incised through
indian ink onto a white ground. 95x68.

Depicts a nude reclining under a tent by a lake.

This design shows a great stylistic affinity to the
illustrations by Dobujinsky for Kuzmin's book
Apuleevsky Lessok for Petropolis in 1922
(S. Makovsky and F. Notgaft, *Grafika M.V.
Dobujinskogo*, 1924, plate between pp.48 and
49).

Coll.: M.V. Braikevitch.

41 *New York rooftops, my window in New York*

Dated '1943'. Oil on cardboard. 550x420.

Also shown in colour on p.106.

Coll.: Mr Rostislav Dobujinsky (the artist's son).
Presented by him to commemorate a Centenary
exhibition held in the Ashmolean Museum in 1975.
Exhib.: Ashmolean, 1975 (No.10).

42 *Design for a backdrop in* Coppelia

Signed and dated: 'Dobujinsky 1945'.
Watercolours and bodycolours. 204x295.

This design was for the production of Delibe's ballet
with the choreography by Zverev planned in 1945
for the Paris Opera, but has not been realised.

Presented anonymously in 1975.

43 *Costume designs for* Coppelia

Signed with a monogram and dated: 'MD 1947'.
Watercolours over black chalk. 257x311.

Presented anonymously in 1975.

44 *A view of the Bourse in St. Petersburg*

43 Dobuzhinsky (Dobujinsky)

Signed and dated: 'M. Dobujinsky 1956' and inscribed on the mount: 'St. Petersbourg. La Bourse. Merry Christmas and a Happy New Year 1956. Graphite. 155x120mm.

Coll.: Gwyneth Talbot. To whom presented as a Christmas card by the artist in 1956.

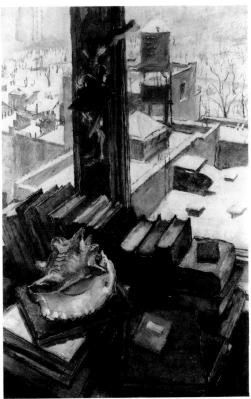

41

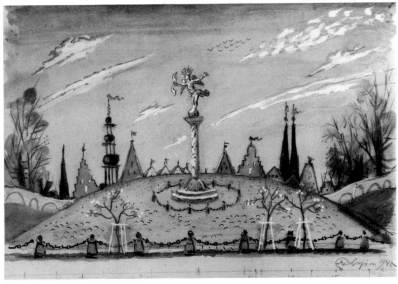

42

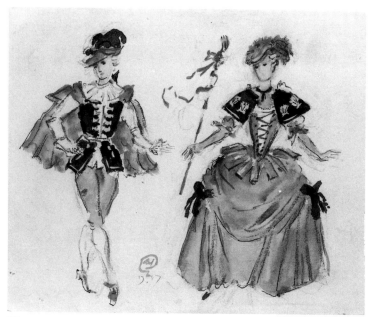

43

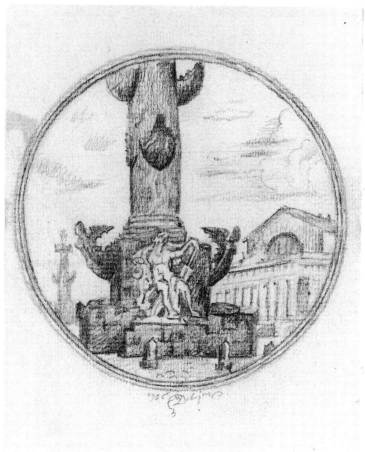

44

Alexandra Alexandrovna Exter

Born Belostok 6 (18) January 1882; died
Fontenay-aux-Roses, near Paris, 17 March 1949.
A graduate of the Kiev Art School, Alexandra Exter
was one of the pioneers of constructivist theatre
décor in Russia. She settled in Paris in 1924, where
she soon became a professor at the Académie
Moderne.

45 *A costume design for Marivaux's play*
La Double Inconstance, *1935*

Signed: 'A. Exter'. Pencil and gouache. 511 x 322.

Also shown in colour on p.98.

Coll.: Simon Lissim. Presented by him in 1974.
Exhib.: 'Alexandra Exter, Artist of the Theatre',
New York Public Library, New York, 1974
(No.83 – repr.).

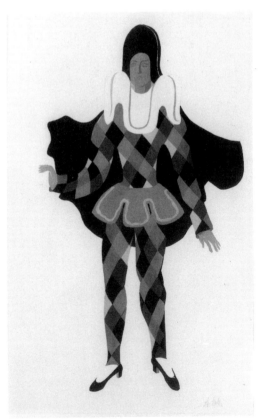

Pavel Andreevich Fedotov

Born Moscow, 22 June (4 July) 1815; died St. Petersburg, 14 (26) November 1852. Started his career as an officer in the Imperial Guards, he soon became known as an amateur painter and after retiring from the army he devoted himself entirely to painting. Fedotov was a prolific draughtsman and one of the first Russian artists to introduce an element of social satire into the treatment of genre subjects.

46 *Preliminary study for a humorous drawing 'This is all very well, but how many serfs do you have?'*

Pencil. 247x164.

An inscription on an old mount runs: 'Эскизъ къ рисунку П. А. Федотова «Это очень хорошо — а сколько у Васъ крестьянъ?»' (см. Живоп. Обозр. No. 45; 1902 г.) Изъ коллекціи Д. Ст. Сов. Константина Карловича Флугъ.'

['Sketch for P.A. Fedotov's drawing "This is all very well, but how many serfs do you have?" (see *Zhivopisnoe obozrenie*, 1902, No.45). From the collection of Konstantin Karlovich Flug.'] A portrait of Dar'ya Karlovna Flug (Konstantin Karlovich's sister) was included in the Exhibition of Russian Portraits in the Tauride Palace in St. Petersburg in 1905 (No.1913); it is now in the Tret'yakov Gallery in Moscow (see the Gallery's *Katalog risunka i akvareli: O.A. Kiprensky . . . P.A. Fedotov*, 1956, p.128.

Coll.: K.K. Flug; Dr. Tatiana Gourlande.

46

Natal'ya Sergeevna Goncharova

Born at Ladyzhino near Tula, 22 May (3 June) 1881; died Paris, 17 October 1962. Studied at the Moscow School of Painting, Sculpture, and Architecture. Started to work for the theatre in K. Kraft's Moscow private studio in 1909. Her theatrical work bears the strong impress of ancient Russian art and folklore with their clear decorative colours and simplified forms. She was one of the pioneers of the 'rayonnist' style in painting.

47 *An exotic tree*

Watercolours. 330 x 409.

Also shown in colour on p.106.

Possibly a detail of the décor for the ballet *Bagatelle* (cf. lot 132 in the catalogue of the Sotheby sale of Diaghilev ballet material on 18 July 1968).

Coll.: Miss Mary Chamot.

48 *Design for a ballet costume*

Inscribed by the artist: 'boucles dorées avec corailles rouge, colier corails rouge. Robe mordoré, bordurs et pans rayé sienne et rouge (chaud) dessous de bras et sinture noire nates brunes petit chapeau tambourin sienne a fond rouge corail et pompon pareil. Pentalons pas très larges, reyures blancs et rose'. Indian ink. 271 x 210.

Coll.: Miss Mary Chamot.

49 *Design for an oriental ballet costume*

Inscribed by the artist: 'bleu marine-verdâtres et re[y]ures étroites rouge corailles – franges rouges coraille – les bas blancs – soulier bleu marine comme sur la sinture et talons coraille – revers oranges – pentalons t[r]ès larges vers le bas et decouvrant la cheville. Chemisette blanche très legers sans manches – bijouterie argent foncé et coraille. Chapeau-calotte argent foncé rose coraille – Jaquette jaune orang, pentalons dans la meme couleur. Sinture orange foncé avec grandes reyures en diagonale.' Indian ink. 268 x 210.

Coll.: Miss Mary Chamot.

50 *Sketch of a woman dancing with a tambourine*

Signed with a monogram: 'N G'. Pencil. 272 x 198.

Coll.: Miss Mary Chamot. **Exhib.**: Arts Council

47

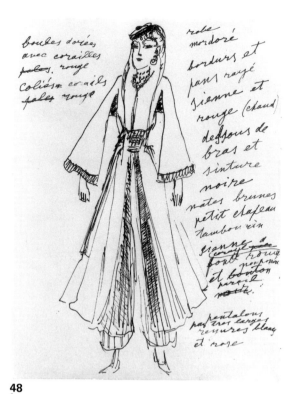

48

49

'Exhibition of Russian Art, Eastbourne'
(subsequently: London, Leeds, and Bristol), 1961.

51 *Sketch of a statuette of a woman dancing*

Signed with a monogram: 'N G'. Pencil. 272 x 198.

Coll.: Miss Mary Chamot.

52 *Design for a ballet*

Watercolours and bodycolours. 284 x 392.

Also shown in colour on p.107.

Coll.: Miss Mary Chamot.

50

51

52

Aleksandr Evgen'evich Jacovleff (Yakovlev)

Born St. Petersburg, 13 June 1887; died Paris, May 1938. Graduated from the St. Petersburg Academy of Fine Arts and quickly gained a reputation for his drawings and highly realistic portraits. His style is sharp, dry, and precise, and is firmly based on that of the old masters – in particular Dürer – though not to the extent of losing its individuality and modern feel. He emigrated in 1918 and in 1924–5 took part in Citroën's *Croisière noire* Sahara expedition.

53 *Portrait of Dr. Tatiana Gourlande with the artist in the background*

Signed, dated, and inscribed: 'A. Jacovleff London June 1920'. Red Chalk. 531 x 430.

Coll.: Dr. Tatiana Gourlande. **Exhib.:** 'Russian Art and Life', Hove, 1961 (No.149).

54 *Houses in the Near East*

Signed and dated: 'A Jacovleff 1923'. Gouache. 262 x 427.

Coll.: Dr. Tatiana Gourlande.

55 *Coastal view (Capri?)*

Signed and dated: 'A. Jacovleff 1923'. Gouache. 262 x 429.

Coll.: Dr. Tatiana Gourlande.

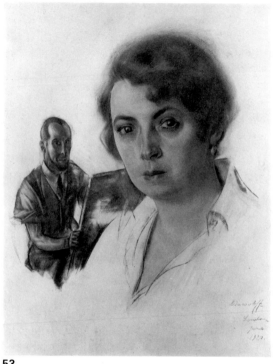

53

54

55

Konstantin Alekseevich Korovin

Born Moscow, 23 November (5 December) 1861; died Paris, 11 September 1939. Graduated from the Moscow School of Painting, Sculpture, and Architecture, where he was in the landscape studio of Savrasov and Polenov. A member of the 'Mir Iskusstva' group. He worked in an impressionist style, devoting himself mainly to landscape, though he also painted portraits and figure compositions. During the years 1885–91 he worked for Savva Mamontov's private opera and in 1898 for the Imperial Opera in Moscow and St. Petersburg. From 1923 onwards he lived in Paris.

56 *Design for the ballet* The Corsair

Signed: 'C. Korovine' and inscribed on the verso.

Oils on cardboard. 410 x 332.

Korovin designed the sets and costumes for the production of *The Corsair* (music by Adam) at the Moscow Bolshoi Theatre in 1915 (see N. Lobanov-Rostovsky, *Russian Painters and the Stage, Transactions of the Association of Russian-American Scholars in the U.S.A.*, ii, 1968, p.184).

Coll.: Dr. Tatiana Gourlande.

57 *Autumn leaves*

Signed and inscribed: 'C. Korovine, Paris'; inscribed on verso: 'Korovine Autumn leaves'. Gouache. 614 x 792.

Décor for the ballet *Autumn Leaves*, first performed in Rio de Janeiro in 1918 (see Ashmolean Museum, *Report of the Visitors*, 1960, p.46).

Coll.: Dr. Tatiana Gourlande. **Exhib.:** 'Anna Pavlova', London Museum, 1936 (No.54).

58 *Design for a ballet*

Signed: 'Constant Korovine' and inscribed on verso: 'Spana. Эскизъ балета'. Oils on thin panel. 150 × 218.

Coll.: Dr. Tatiana Gourlande.

59 *Design for the costume of Zemphira in Rachmaninov's opera* Aleco.

Stamped in mauve in right upper corner: 'Korovine Paris 1925' and inscribed: 'бархать, металлъ не блестящій, легкій крашенный, белыя каймы, холстъ, хвосты'.

56

57

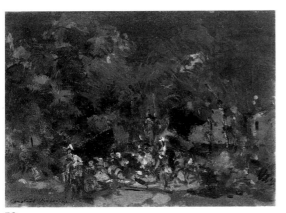

58

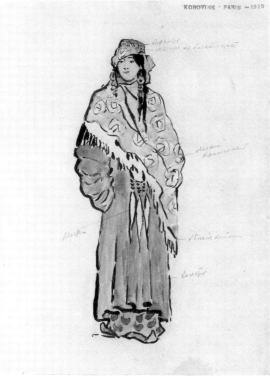

KOROVINE · PARIS – 1925

59

53 Korovin

Bodycolours and indian ink over black chalk. 345×257.

Rachmaninov's one-act opera on the subject of Pushkin's poem *Aleko* was his graduation work of 1892. The date of the Ashmolean drawing can be established by comparing it to another sketch by Korovin, supposedly for the same production, namely the Costume design for an Old Gypsy in the Theatre Museum in Leningrad which is dated 1903. (repr. in *Puti Razvitiya Russkogo Iskusstva konza XIX nachala XX veka, pod redakziey N.J. Sokolovoy i V.V. Vanslova. Izdatelstvo 'Iskusstvo'*, 1972, fig.142, facing p.65. The stamped date 1925 on the drawing must refer to the fact that in 1925 it was in the painter's studio in Paris.

Coll.: Dr. Tatiana Gourlande.

60 *Design for the décor of a scene from the ballet* Fête

Bodycolours with indian ink heightened with silver paint. 322×410.

Fête was based on Diaghilev's *Festin* of 1909 with the music by Glinka, Tchaikovsky, Moussorgsky, Glazunov and Rimsky-Korsakov and choreography drawn from the existing repertoire with finale by Fokine. Korovin designed décor and costumes for Diaghilev and again for Boris Kniaseff's production of *Fête* in 1927. The design is for the finale and comes from Boris Kniaseff's collection.

Coll.: Boris Kniaseff. Purchased in 1969.

61 *View of Paris by night*

Signed: 'Constant Korovine. Paris'. Oils on paper. 330×410.

Coll.: Dr. Tatiana Gourlande.

62 *Sketch of a Russian village*

Signed: 'C. Korovine'. stamped and inscribed on verso: 'Constant Korovine. Россія, деревня. Ночь.'. Oils on cardboard. 140 × 181.

Coll.: Dr. Tatiana Gourlande.

63 *Nocturnal landscape with group round a fire*

Signed: 'Constant Korovine' and stamped in three places on verso: 'Constant Korovine'. Oils on cardboard. 200×370.

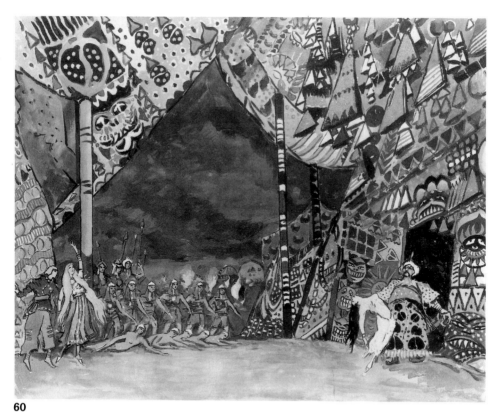

60

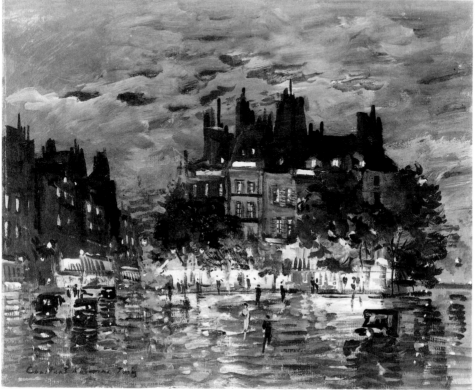

61

62

63

64

65

Coll.: Dr. Tatiana Gourlande.

64 *Winter landscape with a small church*

Signed: 'C. Korovine' and inscribed and stamped
on verso: 'Московской губ. C. Korovine'. Oils on
paper. 115 × 185.

Coll.: Dr. Tatiana Gourlande.

65 *Winter landscape*

Signed: 'C. Korovine' and stamped on verso:
'Constant Korovine'. Bodycolours and oils on
paper. 115 x 185.

Coll.: Dr. Tatiana Gourlande.

66 *Winter landscape with two wooden huts*

Signed: 'C. Korovine' and stamped on verso:
'Constant Korovine'. Bodycolours and oils on
cardboard. 118 x 186.

Coll.: Dr. Tatiana Gourlande.

67 *Winter landscape with a hunter*

Signed: 'C. Korovine' and stamped and inscribed
on verso: 'Constant Korovine. Охотникъ.
Владимирская губ.'. Bodycolours and oils on
cardboard. 120 × 185.

Coll.: Dr. Tatiana Gourlande.

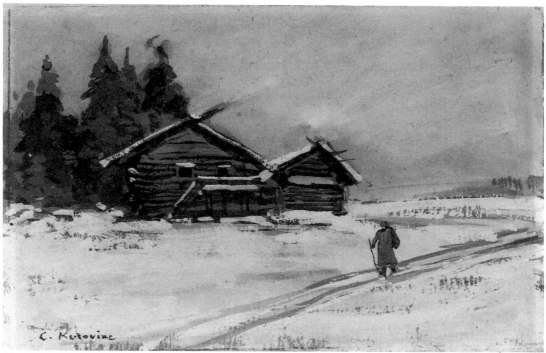

66

67

Mikhail Fedorovich Larionov

Born Tiraspol (Bessarabia), 22 May 1881; died
Fontenay-aux-Roses (France), 10 May 1964.
Graduated from the Moscow School of Painting,
Sculpture, and Architecture. His main interest
always lay in painting in oils; he developed a highly
individual style and work for the theatre occupies
only a minor place in his *œuvre*.

68 *Design for the décor of* Renard

Signed with a monogram: 'М. Л.'. Black chalk
215 × 380.

The ballet *Renard*, with music and libretto by
Stravinsky was one of the most important of
Larionov's works for Diaghilev. It was first
performed at the Paris Opera on 18 May 1922. Ten
drawings for the same production from the artist's
collection were shown at the Diaghilev Exhibition
in Edinburgh in 1954, and two were sold at
Sotheby's on 18 July 1968 (lots 121–2).

Coll.: Miss Mary Chamot.

69 *Sketch of two dancers*

Signed, dated, and inscribed by the artist: 'Для
Мери Михаил ı дек. 1963. M. L.'. Indian ink.
261 × 208.

Coll.: Miss Mary Chamot.

70 *Sketch of a woman seen from behind*

Signed with a monogram: 'M. L.'. Pencil. 245×212.

Coll.: Miss Mary Chamot.

71 *Woman walking with a child*

Reed pen and indian ink on grey paper. 320×230.

Coll.: Miss Mary Chamot.

68

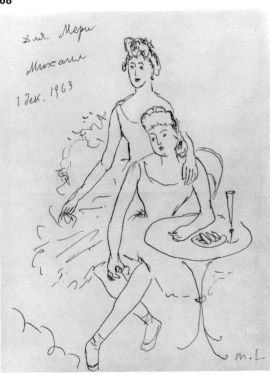

69

70

71

Isaak Il'ich Levitan

Born in the village of Kibarti near Verzhbolovo, 18(30) August 1860; died in Moscow, 22 July (4 August) 1900. The greatest Russian landscape painter. Studied at the Moscow School of Painting, Sculpture, and Architecture from 1873 and taught at the School from 1898, after becoming a member of the Academy of Fine Arts. Took part in the exhibitions both of the 'Peredvizhniki' and the 'Mir Iskusstva' group.

72 *Copse by a lake (Autumn)*

Signed: 'И. Левитанъ'. Oils on paper 111 × 151.

Also shown in colour on p.105.

On stylistic grounds (in particular the painting of the forest) this study can be placed late in Levitan's career. Comparison with other pictures (e.g. 'The Road (Autumn)' of 1897 and especially 'A Day in September' from the Ryabushinsky Collection which is dated 1898 in S. Glagol and I. Grabar', *Levitan*, 1912, pp.79, 88, suggests that it was probably painted in the autumn of 1898 when Levitan was staying on Lake Senezh at Olenin's Bogorodskoe estate near Podsolnechnoe in Central Russia. See also A.A. Fedorov-Davydov, *Levitan* (Moscow, 1966), pp.299, 302–3.

Coll.: M.V. Braikevitch. **Exhib.:** Ashmolean, 1950 (No.32); 'Mir Iskusstva', 1950 (No.23); 'Russian Art and Life', Hove, 1961 (No.125).

72

Semen Mikhailovich Lissim
(Simon Lissim)

Born Kiev, 24 October 1900; died 10 May 1981, Naples, Florida. Studied violin at the Kiev Conservatoire and art under Alexander Monko. Worked in the theatre and was under the influence of Alexandra Exter. Emigrated in 1919 first to Bulgaria and Yugoslavia and in 1921 to Paris where he worked both for the theatre and the Sèvres porcelain factory. In 1941 he settled in the U.S.A. where he taught theatre design at the City College of New York.

73 *Costume for 'The Happiness of Being Rich' in Maeterlinck's* Blue Bird

Signed and dated: 'S. Lissim 23'. Pencil and watercolours. 340 x 262.

Le Oiseau Bleu by Maeterlinck with designs by Simon Lissim was produced at the Théâtre de l'Oeuvre, Paris in 1923.

Presented by the Artist 1976.

Exhib.: 'Dreams in the Theatre. Designs of Simon Lissim', Vincent Astor Gallery, The New York Public Library at Lincoln Center, 1975 and at the Columbus (Ohio) Gallery of Fine Arts, 1976 (No.9).
Lit.: *Perezvony*, 1927 (repr. in colour); John Bowlt, *Russian Stage Design, Scenic Innovation 1900–1930 from the Collection of Mr. and Mrs. Nikita D. Lobanov-Rostovsky*, the Mississippi Museum of Art (Pasgoula at Lamar), 1982, p.206.

74 *A top of the tree*

Signed and dated: 'Simon Lissim 67'. Pencil and watercolours. 300 x 325.

Presented by the Artist 1973.

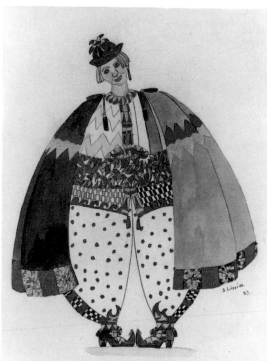

73

74

R. Litvinov

At work during the middle of the nineteenth century. No information is available about this artist.

75 *Portrait of a seated woman*

Signed, dated, and inscribed: 'P. Литвиновъ 1850 г. сентября 13 дня М. Махновка'. Oil on card. 122 × 110.

This and No.76 portray ancestors of Dr. Gourlande.

Coll.: Dr. Tatiana Gourlande.

76 *Portrait of a seated man*

Signed and dated; 'Litvinoff 1851'. Oil on card. 122x107.

See comment under No.75.

Coll.: Dr. Tatiana Gourlande.

75

76

Filip Andreevich Maliavine (Malyavin)

Born in the village of Kazanki (Samara Government) 10(22) October 1869; died in Brussels, 23 December 1940. Began as an icon-painter in the Russian St. Panteleimon monastery on Mount Athos. In 1892 Maliavine entered the Academy of Fine Arts in St. Petersburg where he studied under Repin. Painted principally Russian peasant women in a whirl of bright colours. Emigrated to Western Europe where he continued to work until his death in 1940.

77 *Girl with a flowered shawl*

Signed twice: 'Ph. Maliavine', 'Ф. M.'. Soft pencil with touches of coloured chalk on drab paper. 385 × 285.

An early drawing made soon after Maliavine left the Academy. Probably from the same model as the drawing of 1903 'Two Peasant Women' from the V.O. Girschman collection now in the Moscow Tret'yakov Gallery (repr. in O.A. Zhivova, *Filip Andreevich Malyavin*, 1967, p.161).

Coll.: Dr. Tatiana Gourlande.

77

Leonid Osipovich Pasternak

Born Odessa, 23 March (4 April) 1862; died Oxford, 31 May 1945. Painter and book illustrator. Studied at the Odessa School of Art and at the Academy of Fine Arts in Munich. From 1894 to 1918 taught at the Moscow School of Painting, Sculpture, and Architecture. Exhibited with the 'Peredvizhniki', the Union of Russian Painters, and the 'Mir Iskusstva' group. From 1921 lived abroad, at first in Berlin and later in Oxford.

78 *Portrait of Boris Pasternak as a boy*

Signed and dated: 'Пастернакъ 20. vii. 1898. 20 Iюля 1898'. Black chalk. 254 × 161.

The Russian poet and novelist Boris Pasternak (1890–1960), who was the son of the painter, is here portrayed at the age of eight.

Coll.: Mrs. Josephine Pasternak and Mrs. Lydia Pasternak-Slater. **Exhib.:** 'Memorial Exhibition of Paintings and Drawings by Leonid Pasternak (1862–1945)', Ashmolean Museum, 1958 (No.1); 'Centenary Exhibition of Drawings and Paintings', Herbert Art Gallery and Museum, Coventry, 1962 (No.108); 'Leonid Pasternak 1862–1945', Crawford Centre for the Arts, University of St. Andrews, Graves Art Gallery, Sheffield, MacRobert Art Gallery, University of Sterling, Talbot Rice Art Centre, University of Edinburgh, 1978 (No.14). **Lit.:** Max Osborn, *Leonid Pasternak*, 1932, p.3 (repr.); G. Ruge, *Pasternak, a Pictorial Biography*, 1959, p.9 (repr.).

78

79

79 *Boris Pasternak reading with the nanny standing by*

Signed, dated and inscribed: 'Пастернакъ. Няня и Боря 26/XI900'. pencil. 270 × 170.

Presented by Sir Karl Parker in 1978.

Coll.: Pasternak family; Sir Karl Parker.

80 *Portraits of Boris and Alexander Pasternak*

Signed and dated: 'Пастернакъ. Москва 30. IV. 1905'. Pastel. 428 × 635.

Alexander Pasternak is the artist's younger son.

Presented by Mrs. Pasternak and Mrs. Pasternak-Slater in 1963.

Coll.: Mrs. Pasternak and Mrs. Pasternak-Slater. **Exhib.:** 'Pasternak', Ashmolean, 1958 (No.3); 'Leonid Pasternak', Munich, 1962 (No.4);

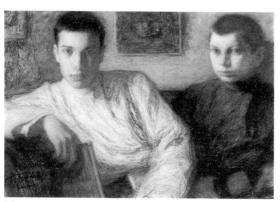

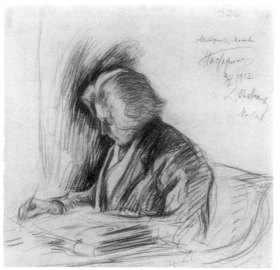

80

81

82

'Pasternak', Museum of Modern Art, Oxford, 1982–83 (No.24). **Lit.**: Max Osborn, *Pasternak*, 1932, p.42 (repr.); G. Ruge, *Pasternak, a Pictorial Biography*, 1959, p.16 (repr.); *Pasternak, Zapisi Raznykh Let*, 1975, p.53, fig.22 (repr.); *The Memoirs of Leonid Pasternak*, 1982, p.114.

81 *Portrait of Edward Gordon Craig*

Signed, dated, and inscribed: '«Метрополь» Москва. Пастернакъ 8/1 1912 L. Pasternak. Moskau.'. Black chalk. 277 × 301.

Edward Gordon Craig was famous for his innovations in theatre productions. At the time when Pasternak's portrait was made he was directing jointly with Stanislavsky and Sullerjizky a new production of *Hamlet* for the Moscow Art Theatre. The finished portrait belonged to the sitter.

Coll.: Mrs. Pasternak and Mrs. Pasternak-Slater. **Exhib.**: 'Pasternak', Ashmolean, 1958 (No.8); Coventry, 1962 (No.109); 'Leonid Pasternak', Oxford University Press, Ely House, London, 20 March to 30 May 1969 (No.67); 'Leonid Pasternak 1862–1945', Crawford Centre for the Arts, University of St. Andrews, Graves Art Gallery, Sheffield, MacRobert Art Gallery, University of Sterling, Talbot Rice Centre, University of Edinburgh, 1978 (No.42); 'Pasternak', Museum of Modern Art, Oxford, 1982–83 (No.69).

82 *The vegetable garden*

Signed and dated: 'Пастернакъ 26/VII 18'. Pastel colours, black chalk, and conté stick. 254 × 405.

Also shown in colour on p.107.

Coll.: Mrs. Pasternak and Mrs. Pasternak-Slater. **Exhib.**: 'Pasternak', Ashmolean, 1958 (No.27); 'Pasternak', Crawford Centre for the Arts, University of St. Andrews, Graves Art Gallery, Sheffield, MacRobert Art Gallery, University of Sterling, Talbot Rice Centre, University of Edinburgh, 1978 (No.60); 'Pasternak', Museum of Modern Art, Oxford, 1982–83 (No.69).

83 *The yellow tree: Autumn landscape*

Watercolours and black chalk. 374 × 215.

Also shown in colour on p.109.

The landscape is near Moscow and the watercolour was painted in 1918.

83

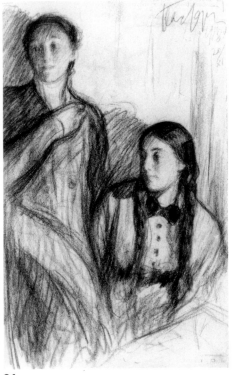

84

Coll.: Mrs. Pasternak and Mrs. Pasternak-Slater.
Exhib.: 'Pasternak', Ashmolean, 1958 (No.28);
'Pasternak', Museum of Modern Art, Oxford,
1982–83 (No.92).

84 *The artist's daughters Josephine and Lydia
beside a stove*

Signed and dated: 'Пастернакъ. 20 XI 1918'.
Black and red chalks on pale buff paper.
420 × 264.

Also shown in colour on p.111.

Coll.: Mrs. Pasternak and Mrs. Pasternak-Slater.
Exhib.: 'Pasternak', Ashmolean, 1958 (No.30).

85 *Three studies of Lenin*

Signed: 'Л. Пастернакъ'. Black chalk and stump.
303 × 233.

Drawn from life at a meeting of the Third International
in Moscow in 1920. Another study is now in the
Tret'yakov Gallery in Moscow (repr. in Osborn,
Pasternak, 1932, p.90).

Coll.: Mrs. Pasternak and Mrs. Pasternak-Slater.
Exhib.: 'Pasternak', Ashmolean, 1958 (No.34);
'Leonid Pasternak 1862–1945', Crawford Centre
for the Arts, University of St. Andrews, Graves Art
Gallery, Sheffield, MacRobert Art Gallery, University
of Sterling, Talbot Rice Centre, University of
Edinburgh, 1978 (No.74 – repr.); 'Pasternak',
Museum of Modern Art, Oxford, 1982–83 (No.75).
Lit.: *Pasternak Zapisi Rasnykh Let*, 1975, p.155
(repr.); *The Memoirs of Leonid Pasternak*, 1982,
pl.42 (repr.).

86 *Portrait of Rainer Maria Rilke*

Signed: 'L. Pasternak'. Charcoal and watercolours
touched with pastel. 580 × 440.

Also shown in colour on p.111.

The Austrian poet Rilke (1875–1925) is seen
against a background of the churches of the
Kremlin in Moscow. Painted in Germany between
1921 and 1924. The finished portrait for which this
is a study was presented by Professor von Mises to
Harvard University; it is reproduced in Osborn,
Pasternak, 1932, p.96. Another study in oil is at
present in the Neue Pinakothek in Munich (repr. in
The Memoirs of Leonid Pasternak, 1982, pl.45).

Purchased in 1958.

85

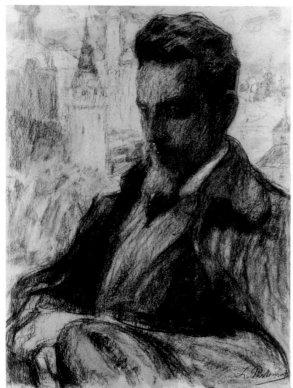

86

Coll.: Mrs. Pasternak and Mrs. Pasternak-Slater.
Exhib.: 'Pasternak', Ashmolean, 1958 (No.46; repr. as pl.V in the Catalogue); 'Leonid Pasternak 1862–1945', Crawford Centre for the Arts, University of St. Andrews, Graves Art Gallery, Sheffield, MacRobert Art Gallery, University of Sterling, Talbot Rice Centre, University of Edinburgh, 1978 (No.82); 'Pasternak', Museum of Modern Art, Oxford, 1983 (No.77).

87 *Preparatory drawing for the portrait of Rainer Maria Rilke*

Inscribed by the artist: 'церкви — все вверхъ клубится'. Black chalk. 208 × 162.

On loan since 1958.

Coll.: Mrs. Pasternak and Mrs. Pasternak-Slater.
Exhib.: 'Leonid Pasternak', O.U.P., 1969 (No.64).

88 *Preparatory drawing for the portrait of Rainer Maria Rilke*

Black chalk. 208x162.

On loan from the family, 1958 to 1981.

Coll.: Mrs. Pasternak and Mrs. Pasternak-Slater.
Exhib.: 'Leonid Pasternak', O.U.P., 1969 (No.64a).

89 *Preparatory drawing for the portrait of Rainer Maria Rilke*

Watercolours over black chalk. 215x160.

On loan since 1958.

Coll.: Mrs. Pasternak and Mrs. Pasternak-Slater.
Exhib.: 'Leonid Pasternak 1862–1945', Crawford Centre for the Arts, University of St. Andrews, Graves Art Gallery, Sheffield, MacRobert Art Gallery, University of Sterling, Talbot Rice Centre, University of Edinburgh, 1978 (No.83).

90 *Portrait of Albert Einstein*

Inscribed by the artist: 'Einstein'. Pencil and stump. 251x196.

A study for the portrait of Albert Einstein (1879–1956) painted in Berlin in 1924 and now belonging to the Hebrew University of Jerusalem; it is reproduced in Osborn, *Pasternak*, 1932, p.70.

Coll.: Mrs. Pasternak and Mrs. Pasternak-Slater.

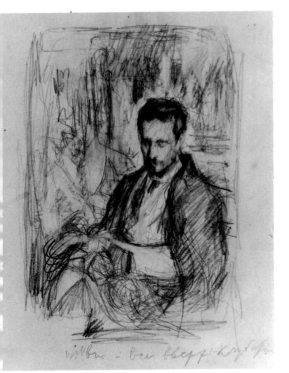

87

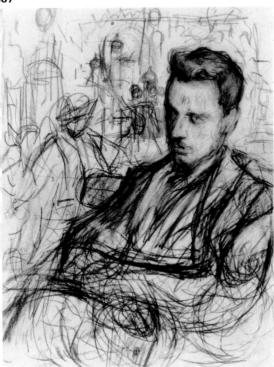

88

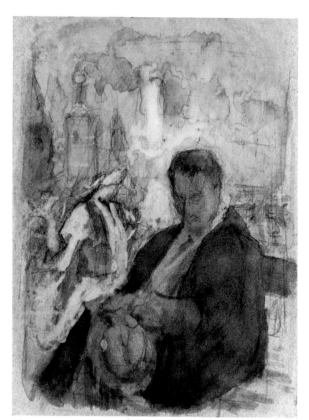

89

90

91

92

Exhib.: 'Pasternak', Ashmolean, 1958 (No.47); Coventry, 1962 (No.111); 'Leonid Pasternak', O.U.P., 1969 (No.63); 'Leonid Pasternak 1862–1945', Crawford Centre for the Arts, University of St. Andrews, Graves Art Gallery, Sheffield, MacRobert Art Gallery, University of Sterling, Talbot Rice Centre, University of Edinburgh, 1978 (No.84); 'Pasternak', Museum of Modern Art, Oxford, 1983 (No.80).

91 *Self-portrait*

Signed: 'Пастернакъ'. Pencil. 285 × 213.

Drawn in Germany between 1925 and 1938.

Coll.: Mrs. Pasternak and Mrs. Pasternak-Slater. **Exhib.**: 'Pasternak', Ashmolean, 1958 (No.69; repr. as Catalogue frontispiece); Coventry, 1962 (No.112). **Lit.**: *The Memoirs of Leonid Pasternak*, 1982, pl.19 (repr.).

92 *Study for the portrait of Leo Tolstoy*

Signed in three places; twice: 'Л. Пастернакъ', and once: 'L. Pasternak'. Black chalk. 280 × 207.

This study looks as if it may have been made from life, since it closely resembles the many sketches which Pasternak made of Tolstoy and his family at Yasnaya Polyana in 1901 (for these see the 'Mir Iskusstva' Exhibition of 1902 and the journal *Mir iskusstva*, 1902, nos.8–9, pp.66–7).

Coll.: Mrs. Pasternak and Mrs. Pasternak-Slater. **Exhib.**: 'Pasternak', Ashmolean, 1958 (No.70); 'Leonid Pasternak 1862–1945', Crawford Centre for the Arts, University of St. Andrews, Graves Art Gallery, Sheffield, MacRobert Art Gallery, University of Sterling, Talbot Rice Centre, University of Edinburgh, 1978 (No.64); 'Russian Graphic Art XVIII–XX cc', The Hatton Gallery, University of Newcastle-upon-Tyne, 1978, Sainsbury Centre, Norwich, 1979–80 (No.160). **Lit.**: *The Memoirs of Leonid Pasternak*, 1982, pl.56 (repr.).

93 *Mendelssohn conducting Bach's St. Matthew Passion*

Signed and dated: 'L. Pasternak 1930'; inscribed on verso: 'Bach'. Black chalk. 805×568.

A preparatory sketch for the painting of 1930, bought by W. Loeb of New York. In his unpublished memoirs the artist records: 'One of my last works in Germany was a painting "Mendelssohn conducts Bach's St. Matthew Passion". To Germany's shame

her greatest genius, Johann Sebastian Bach, was
so neglected in his own day that when he died in
extreme poverty he was buried in a common grave,
and later it was impossible to tell which coffin was
actually his. And it was a young man of twenty-one,
Felix, the grandson of the well-known philosopher
Moses Mendelssohn, who – to his eternal credit –
revived the music of Bach. In 1829, a hundred years
after it was written, he conducted the St. Matthew
Passion. To make the subject clearer I treated it as
the Italian masters used to do by showing two scenes
in the same picture. Bach rising from his coffin in
the upper part and Mendelssohn conducting the
orchestra below . . .'. This passage from Leonid
Pasternak's memoirs is quoted by courtesy of
Mrs. Josephine Pasternak.

Purchased from Mrs. Pasternak-Slater in 1966.

Coll.: Mrs. Pasternak-Slater. **Exhib.**: 'Leonid
Pasternak 1862–1945', Crawford Centre for the
Arts, University of St. Andrews, Graves Art Gallery,
Sheffield, MacRobert Art Gallery, University of
Sterling, Talbot Rice Centre, University of Edinburgh,
1978 (No.109).

93

94 *Roses in a vase*

Signed: 'L. Pasternak'. Watercolours, bodycolours,
and pastel over black chalk. 465x120.

Presented anonymously in 1967 in memory of Jane
Baden-Powell (St. Hilda's College, 1922–24).

Coll.: Mrs. Pasternak and Mrs. Pasternak-Slater.

Given by the daughters of the artist to the donor in
commemoration of the exhibition of the artist's
work held at the Ashmolean Museum in 1958.

95 *Arranging flowers*

Signed and inscribed: 'Л. Пастернакъ L. P.
оборотъ'. Watercolours over black chalk.
368 × 258.

Coll.: Mrs. Pasternak and Mrs. Pasternak-Slater.
Exhib.: 'Pasternak', Ashmolean, 1958 (No.80);
Coventry, 1962 (No.113).

96 *Still-life: tomatoes and cucumbers*

Signed: 'L. Pasternak'. Watercolours. 161x206.

Coll.: Mrs. Pasternak and Mrs. Pasternak-Slater.
Exhib.: 'Pasternak', Ashmolean, 1958 (No.83).

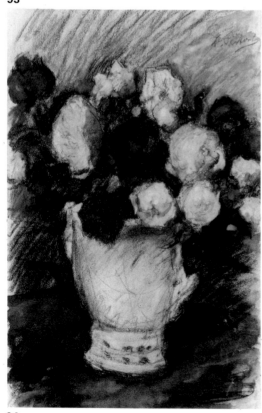

94

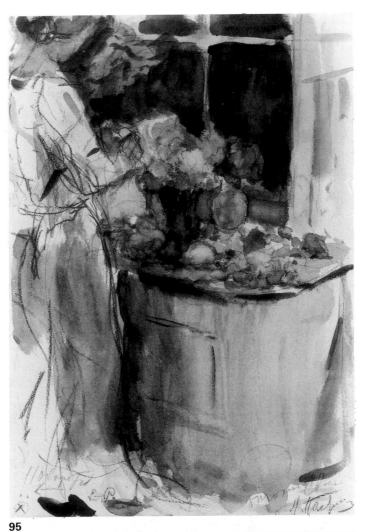

95

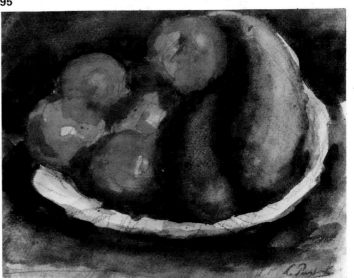

96

Nikolay Konstantinovich Roerich (Rerikh)

Born St. Petersburg, 27 September (9 October) 1874; died at Kulu in the Himalayas on 13 December 1947. A man of extremely wide interests and talents and a most prolific painter of great originality (he painted more than 7,000 pictures). He graduated from the University and from the Academy of Fine Arts in St. Petersburg and started his professional life as an archaeologist. His paintings were always related to his archaeological and anthropological interests. His deep historical knowledge and understanding give great authority to his stage designs. The best known of these are for the 'Polovtsian Dances' in *Prince Igor,* shown during Diaghilev's 1909 Paris season, and for the original production of the *Sacre du Printemps* at the Théâtre du Châtelet in May 1913. From 1916 Roerich lived first in Finland and then in the other Scandinavian countries. In 1920–3 he toured America with his pictures, enjoying an unprecedented success. In 1923 he went with his family on an anthropological expedition to India and Central Asia. In 1926 he returned to Moscow and soon embarked on a fresh expedition – this time to the Altai, Mongolia, and Tibet. From 1928 until his death he lived in the Himalayas at Kulu (some 60 miles N. of Simla) where he directed an Institute of Himalayan Research.

97

97 *Design for the décor for the Polovtsian Dances*

Pastel and pencil on reddish paper. 144 x 187.

Also shown in colour on p.105.

Sketch for the design for the 'Polovtsian Dances' from Borodin's opera *Prince Igor* for the Diaghilev production in Paris in May 1909. This may be the one mentioned as belonging to the artist's wife, Elena Ivanovna Roerich, from whom we know that Braikevitch bought her portrait painted by Serov (see J.K. Baltrušaitis, A.N. Benois, A.I. Gidoni, A.M. Remizov, S.P. Yaremich, *Nikolay Konstantinovich Rerikh*, 1916, p.143). Several versions of this set are known: the earliest is in the Tret'yakov Gallery in Moscow and is dated 1907 (repr. in V.P. Knyaz'eva, *N. Rerikh*, 1968, pl.10); another is in the Russian Museum in Leningrad, and a third is in the Victoria and Albert Museum in London (col. repr. in C. Gray, *The Great Experiment,* 1962, facing p.38).

Coll.: M.V. Braikevitch. **Exhib.:** 'Mir Iskusstva', London, 1950 (No.24); 'Diaghilev', Edinburgh, 1954 (No.45) and London, 1955 (No.4); '50 Years of Ballet Designs', Indianapolis, John Herron Museum, 1959; Hartford, Wadsworth Atheneum, 1959 (id.); San Francisco, The California Palace of the Legion of Honor, 1959 (id.); New York, The

American Federation of Arts, 1960 (id.); 'Russian
Graphic Art XVIII-XX cc', Newcastle, November
1978; Sainsbury Centre, Norwich, 1979–80
(No.164). **Lit.:** V. Svetlow, *Le Ballet Contemporain,
ouvrage édité avec la collaboration de L. Bakst*,
1912 (repr. opp. p.96).

98

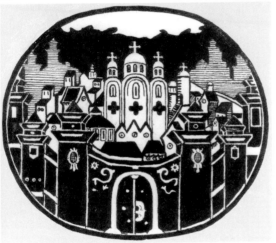

99

98 *The forefathers*

Signed and dated: 'Рерихъ, 1911'. Tempera on
canvas. 693 × 898.

Also shown in colour on p.108.

This is a preparatory cartoon for the mosaic
over the entrance on the Princess's Tenisheva
estate 'Talashkino' near Smolensk. Roerich was
responsible both for the architecture of the church
and its exterior and interior decoration. The subject
of this panel reflects Roerich's interests in pagan
folklore. Knyaz'eva relates it to the legends of
Yaroslavl, where as late as the eleventh century the
bear was considered to be a sacred animal. Serge
Ernst sees in it a Russian version of the Orpheus
myth. Roerich repeated the composition in the
1940s in a picture which is now in the Russian
Museum in Leningrad, (repr. Knyaz'eva, *Rerikh*,
1968, No.14).

Coll.: B.V. Sleptsov; M.V. Braikevitch.
Exhib.: 'Russian Art and Life', Hove, 1961
(No.97). **Lit.:** J.K. Baltrušaitis *et al., Rerikh,* 1916,
(reproduced facing p.96 the sketch for the picture
in E.I. Roerich's collection); S. Ernst, *N.K. Rerikh,*
1918, (repr. on p.48, discussed on pp.90, 121);
V.P. Knyaz'eva, *N. Rerikh,* 1968, p.18.

99 *A Russian town – vignette*

Signed: 'Н. Рерихъ'. Indian ink over pencil.
75 × 88 (oval).

This design was made by Rerikh in 1920 for the
cover of *The Russian Economist. Journal of the
Russian Economic Association,* published in
London in 1920–23. Braikevitch was an honorary
secretary and editor of this journal.

Coll.: M.V. Braikevitch. **Exhib.:** Ashmolean, 1950
(No.6; repr. on cover of the Catalogue); 'Diaghilev',
Edinburgh, 1954 (No.45) and London, 1955
(No.4). **Lit.:** T. Braikevitch, *An Outline of Russian
Art leading to the Period Known as Mir Iskusstva,*
1950 (repr. on cover).

Rom (Romanov)

100

101

Russian caricaturist active at the beginning of the twentieth century.

100 *Company at the table drinking*

Signed: 'POM'. Inscribed on the back by the artist: 'Яковлевъ Кропотовъ Романовъ Подпаловъ Селивановъ Мангутовъ Sgt. Bovill.'

Inscribed by a fellow prisoner in the camp, Sir George Clark: 'This drawing by Romanov, who is represented in it, shows Russian officers in the prison camp at Gättenhohe in Westfalen in 1916. I think most of them belonged to the second Guards Regiment. The bearded man is a Chinovnik. The figure in the background was an English Mess-Sergeant. Inscribed by John Simmons: 'The above notes are in the hand of Sir George Clark, a fellow prisoner of the artist, who gave me the caricature this day, 22 July 1968.' All Souls College, Oxford, John Simmons. Pen, indian ink and watercolours. 285 x 384.

Coll.: Sir George Clark; John Simmons. Presented by Mr. J.S.G. Simmons, 1986.

101 *Officer smoking with two bottles in his pockets*

Signed: 'POM'. Inscribed on the back by the artist: 'Кеденко'. Inscribed on the back by John Simmons: 'One of two Russian caricatures given to me by Sir George Clark on 22 July 1968. John Simmons.' Pen, indian ink and watercolours. 352 × 200.

Coll.; Sir George Clark: John Simmons. Presented by Mr. J.S.G. Simmons, 1986.

Vasily Ivanovich Schouhaiev (Shukhaev)

Born Moscow 12 (24) January 1887; died Tbilisi 1973. Studied at the Stroganov Art School in Moscow from 1897 to 1905. From 1906 until 1912 was at the St. Petersburg Academy of Fine Arts from which he graduated at the same time as Alexander Jacovleff. He is best known for his portraits, stage designs, and book illustration work. In 1920 he emigrated to Paris, returning to the U.S.S.R. in 1935. He was soon arrested and exiled to Magadan, where for ten years he was the designer at the local theatre. In 1947 he began to teach at the Academy of Fine Arts in Tbilisi in Georgia, where he remained until his death in 1973.

102

102 *At the ball*

Signed and dated: 'V. Choukhaeff 1922'. Brush and indian ink touched with white. 108 x 190.

Both this drawing and No.103 are illustrations for the edition of Pushkin's *Queen of Spades* published by La Pléiade in Paris in 1922 (see N. Lobanov-Rostovsky, 'Russian Painters and their Activity for the Stage, 1885–1935', *Transactions of the Association of Russian-American Scholars in the U.S.A.*, ii 168, p.195 and N.D. Sosnovskaya and Zh.B. Rybakova, *Vasily Ivanovich Shukhaev: katalog vystavki,* 1968, p.6).

Coll.: Dr. Tatiana Gourlande. **Exhib.:** Brussels Salon, 1923 (No.7).

103

103 *The letter*

Signed and dated: 'V. Choukhaeff 1922'. Brush and indian ink touched with white. 108 x 190.

See comments under No.102.

Coll.: Dr. Tatiana Gourlande. **Exhib.:** Brussels Salon, 1923 (No.7).

Valentin Aleksandrovich Serov

Born St. Petersburg, 7 (19) January 1865; died
Moscow, 22 November (5 December) 1911. By far
the best Russian portraitist of his time, Serov
also worked in other genres: landscape, book
illustration, etc. He was a member of a family of
famous musicians (both his parents were
composers) and started to paint very early, at first
under Repin and later in the Academy of Fine Arts
in St. Petersburg (1880–5) – to which he was
admitted at the exceptionally early age of fifteen.
He was equally popular with the 'Peredvizhniki'
and the 'Mir Iskusstva' group and won himself
an unchallengeable reputation through his
exceptionally serious and uncompromising attitude
to his work. Neither the passage of time nor the
different political and artistic climate prevailing in
Russia today has affected the appreciation of Serov.

104

104 *Study of a model with the attributes of
Bacchus.* (On verso) *Study of a bronze
statuette*

Inscribed on an old mount: 'Авторъ: В. А.
Съровъ. Названіе: Акварель костюмнаго
класса. Собственникъ: О. ⊖. Сърова, Москва,
Плющиха, 14', indicating that the drawing
comes from the collection of the artist's wife.
Watercolours. 190 × 176.

During his time at the Academy of Fine Arts, Serov
became infatuated with the art of Mikhail Vrubel' –
then a student, though his senior by ten years.
Vrubel' wrote to his sister in 1883: 'After Serov and
Derviz knew that I had rented a private studio, they
asked me to join them in painting in watercolours a
model in Renaissance costume (the costume and
trimmings taken for the house of Derviz's uncle, the
well-known millionaire). I was to pay for the studio
and they for the model.' Vrubel's own watercolour:
Model with the Attributes of Bacchus, is now in
the Russian Museum in Leningrad (No. P.13468)
and is signed and dated 1884. Its composition is
identical with the Ashmolean study, but it is a more
finished performance.

Coll.: O.F. Serova; Dr. Tatiana Gourlande.

105 *Hunger*

Pen with some watercolour over pencil. 257 x 185.
(Made-up on right, in left lower corner, and
repaired in three other places.)

During the early 1890s Valentina Semenovna
Serova, the artist's mother, helped to organize
canteens for the starving peasants in the Simbirsk
region. Serov's drawing reflects this experience.
Another – and undoubtedly earlier – version,

105

identical in composition, is in the Russian Museum in Leningrad (No. P.13406). It is far more detailed and less expressive in its contours. It was Serov's usual practice to eliminate the less important features in later versions of his works. An old label on the back of the original mount gives the address of a shop in Kiev ('Kreshchatik 58'), the price of the drawing (350 roubles), and the name of the owner (O.F. Serova, the artist's wife).

Coll.: O.F. Serova; Dr. Tatiana Gourlande.
Exhib.: 'Russian Art and Life', Hove, 1961 (No.166). **Lit.:** V.S. Serova, *Kak ros moi syn,* 1968 (repr.).

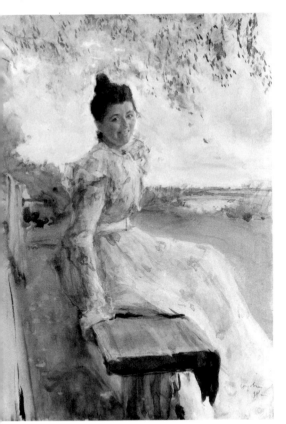

106

106 *Portrait of the Countess Musin-Pushkin in a garden*

Signed and dated: 'Съровъ 98'. Watercolours and bodycolours. 535 × 369.

Serov painted Countess Varvara Vasil'evna Musin-Pushkin several times. Serge Ernst reports that this portrait was painted on the Count's estate at Borisoglebsk in the Molozhsky District, and was acquired from the Countess by Braikevitch in Paris. When it was exhibited in London in 1935 it was still in the possession of the family. Pencil studies for the companion portrait of the Count are now in the Tret'yakov Gallery in Moscow (see the Gallery's *Katalog risunka i akvareli: Polenov . . . Serov . . .,* 1956, p.63.

Coll.: Countess Musin-Pushkin; M.V. Braikevitch.
Exhib.: 'Exhibition of Russian Art', London, 1935 (No.439); Ashmolean, 1950 (No.35); 'Mir Iskusstva', London, 1950 (No.2); 'Russian Art and Life', Hove, 1961 (No.139). **Lit.:** I. Grabar', *Valentin Serov,* 1913, p.115 (repr.), p.142; S. Ernst, *V.A. Serov,* 1921, p.42.

107 *Portrait of Elena Ivanovna Roerich*

Signed with a monogram and dated: 'B C 909'. Black chalk, pastels, and watercolours on straw-coloured paper. 648 x 466.

Also shown in colour on p.112.

Depicts the wife of the artist Nikolay Konstantinovich Roerich. Serge Ernst reports that Braikevitch acquired the portrait direct from the sitter.

Coll.: E.I. Roerich; M.V. Braikevitch. **Exhib.:** 'Portraits of Women' (Apollon), St. Petersburg, 1910; Ashmolean, 1950 (No.36); 'Mir Iskusstva', London, 1950 (No.3). **Lit.:** *Apollon,* 1910, No.5

107

(Feb.), p.7 (repr.); I. Grabar', *Serov*, 1913, p.216 (repr.); S. Ernst, *Serov*, 1921, facing p.81.

108 *Standing female figure with chair*

Authenticated on verso in the hand of the artist's wife: 'Удостоверяю работу В. А. Сърова. О. ⊖. Сърова.'. Black chalk. 397 × 223.

Drawings of models with accentuated contour-lines are characteristic of Serov's later style, dating from the time when he visited Bakst and Diaghilev in Paris. They were intended for collectors and many of them are in public and private collections in Russia. Similar to Ashmolean Nos.107–108 are Nos.37–9 in the album of 1910 in the Tret'yakov Gallery in Moscow (see p.185 of the Gallery's Catalogue referred to under No.106 above). The inscription on the verso shows that the drawing was sold by Serov's widow after his death.

Coll.: O.F. Serova; M.V. Braikevitch. **Exhib.:** Ashmolean, 1950 (No.34); 'Russian Art and Life', Hove, 1961 (No.165).

109 *Standing female figure*

Stamped: 'B C'. Black chalk. 395 × 227.

See comments under No.108.

Coll.: M.V. Braikevitch. **Exhib.:** Ashmolean, 1950 (No.33).

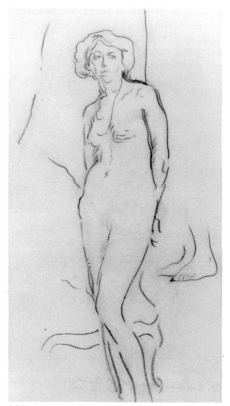

108

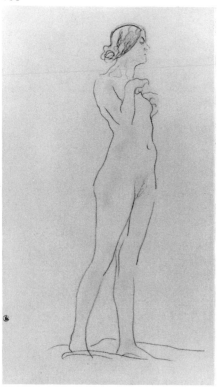

109

Konstantin Andreevich Somov

Born St. Petersburg, 19 November (1 December) 1869; died Paris, 6 May 1939. Son of the Keeper of the Department of Painting of the Hermitage Museum in St. Petersburg, Konstantin Somov studied at the Academy of Fine Arts under Repin. A member of the 'Mir Iskusstva' group. He was a fine portraitist and a prolific book illustrator and also had a reputation as a painter of erotic scenes. He emigrated in 1924 – first to America, and then to Paris.

110 *Landscape with grey clouds*

Signed and dated: 'К. Сомовъ 28 май 1897'. Watercolours and bodycolours. 430 × 287.

Also shown in colour on p.109.

This watercolour belonged to Russian painter, collector and mecenas Prince Scherbatoff and was mentioned in the early biography of Somov by Oscar Bie. Braikevitch owned a similar watercolour which Somov painted one month later and which was left with the rest of his collection in Odessa and now belongs to the Odessa Museum of Russian Art (*Konstantin Andreevich Somov, Katalog vistavki k 100 letiu so dnia rojdenia hudojnika, 'Iskusstvo'*, 1971, p.36).

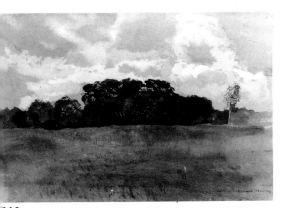

110

Coll.: Prince Scherbatoff; M.V. Braikevitch.
Exhib.: 'Exhibition of Constantine Somov Painting', Prince Vladimir Galitzine Gallery, London, 1930 (No.52); Ashmolean, 1950 (No.37); 'Mir Iskusstva', London, 1950 (No.10). **Lit.:** O. Bie, *Constantin Somoff,* 1907, p.46; S. Ernst, *K.A. Somov,* 1918, p.90.

111 *Design for the costume of Colombine for Anna Pavlova in* Arlekinade

Signed and dated: 'К. Сомовъ 09', Pencil and watercolours. 306 × 218.

Also shown in colour on p.100.

Fokine's ballet *Arlekinade* with music by Schumann was first performed in the Maryiinsky theatre in St. Petersburg in 1909. The inscriptions on two preliminary drawings which were in the collection of Prince Argutinsky-Dolgorukov and now in Leningrad 'Dlia kostuma Pavlovoi dlia Arlekinadi' specify the purpose of this drawing (repr. in J.N. Podkopaeva and A.N. Sveshnikova, *Somov,* 1979, pl.36).

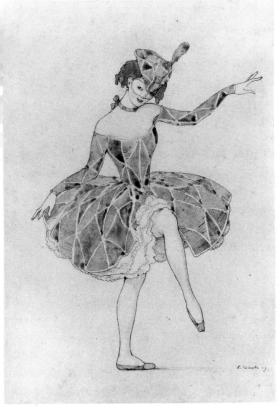

111

Coll.: A.P. Pavlova; Dr. Tatiana Gourlande. **Lit.:** Serge Ernst, *Somov,* 1918, p.105; J.N. Podkopaeva and A.N. Sveshnikova, *Somov,* 1979, p.76.

112 *Portrait of Evgheniy Sergheevich Mikhailov, the painter's nephew*

Signed and dated: 'К. Сомовъ 1916'. Canvas, oil. 720 × 550.

Also shown in colour on p.112.

The creation of this portrait occupies a considerable place both in the diaries of Somov and in the memoires of his nephew published together by Podkopaeva and Sveshnikova, op. cit., pp.156–159 and on many other occasions. According to his diary Somov sold this portrait to Braikevitch in 1938: 'He thinks that the portrait is equal in quality to the portrait of a bald young man by Prudhon . . .'

Coll.: M.V. Braikevitch. **Lit.:** J.N. Podkopaeva and A. Sveshnikova, *Somov*, 1979, pl.51 (repr.).

113 *Study for a costume of a marquise for Mme Karsavina*

Signed and dated: 'C. Somoff 1924'. Bodycolours and watercolours over pencil. 211 x 168.

Coll.: M.V. Braikevitch. **Exhib.:** 'Exposition d'Art Russe Ancien et Moderne', Palais des Beaux-Arts de Bruxelles, 1928 (No.337); 'Exposition Russe', Berlin, 1930 (No.107); 'Somov', London, 1930 (No.37); Ashmolean, 1950 (No.39).

112

114 *The embrace*

Signed and dated: 'K. Somov, 1927'. Watercolours and bodycolours. 82 x 58.

Coll.: M.V. Braikevitch. **Exhib.:** 'Somov', London, 1930 (No.8); Ashmolean, 1950 (No.41).

115 *Under the pergola*

Signed and dated: 'C. Somof, 1927'. Watercolours and bodycolours. 117 x 81.

Coll.: M.V. Braikevitch. **Exhib.:** 'Somov', London, 1930 (No.10); Ashmolean, 1950 (No.40).

116 *The mirror*

Signed and dated: 'C. Somoff 11 novembre 1927'. Watercolours and bodycolours. 86 x 76.

Somov mentions this drawing in a letter of 13 November 1927 addressed to his sister in Leningrad: 'I am busy now as I am working with

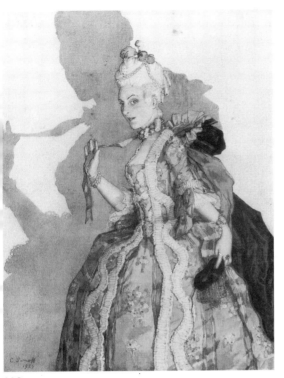

113

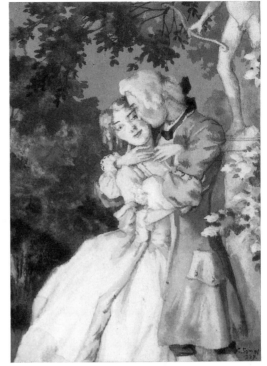

114

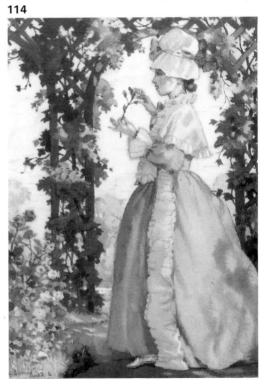

115

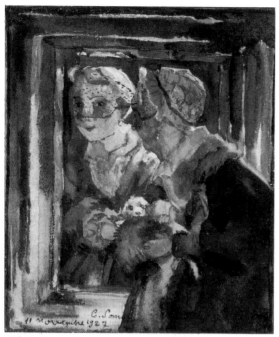

116

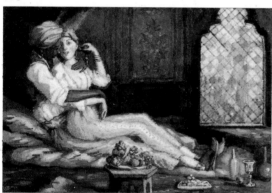

117

118

pleasure on a miniature: an eighteenth-century lady looking into a mirror – everyone wants eighteenth-century things from me. In the mirror you can see the lady *en trois quarts* and the same lady in the foreground *en profil perdu* and a bit *contre jour*.' (Russian Museum in Leningrad, Somov archive, fond 136).

Coll.: M.V. Braikevitch. **Exhib.:** 'Somov', London, 1930 (No.14); Ashmolean, 1950 (No.42). **Lit.:** J.N. Podkopaeva and A.N. Sveshnikova, *Somov*, 1979, p.324.

117 *Arabian night*
 (Moorish interior)

Signed: 'C. Somov'. Bodycolours. 45x65.

Coll.: M.V. Braikevitch. **Exhib.:** 'Somov', London, 1930 (No.11).

118 *Winter walk*

Signed and dated: 'C. Somof 1928'. Bodycolours. 92x140.

Repetition of an early picture, painted in 1897, which was in the collection of I.I. Troyanovsky (see S. Ernst, *Somov*, 1918, p.89).

Coll.: M.V. Braikevitch. **Exhib.:** 'Somov', London, 1930 (No.18); Ashmolean, 1950 (No.43).

119 *Lady with a dog*

Signed and dated: 'C. Somof 28'. Watercolours and bodycolours. 75x72.

Coll.: M.V. Braikevitch. **Exhib.:** 'Somov', London, 1930 (No.15); Ashmolean, 1950 (No.44).

120 *Porcelain figures on a mantelpiece*

Signed and dated: 'C. Somov октябрь 1928'. Pencil on grey-blue paper, heightened with white. 278 × 322.

Apparently one of two studies for the picture which Somov mentions in a letter to his sister of 27 April 1930: 'I am painting a new picture in bodycolours, comparatively big for me, for the exhibition in London. The subject is very attractive and I have two studies for it: one in pencil and one in pastel. There is a mantelpiece with porcelain figures reflected in the mirror above it, and you can also see a window in perspective and trees beyond it –

119

120

all in reflection. They are lighted by the street lamp from below.'

Coll.: M.V. Braikevitch. **Exhib.:** Ashmolean, 1950 (No.46). **Lit.:** J.N. Podkopaeva and A.N. Sveshnikova, *Somov,* 1979, p.365.

121

121 *Self-portrait in a mirror*

Signed and dated: 'C. Somof 1928', Pastel. 372×268.

Also shown in colour on p.110.

On New Year's Eve 1928 Somov wrote to his sister: 'Yesterday I finished my self-portrait in pastel, commissioned by my friend in London. . . . The likeness is good, only the face is gloomy and the eyes are piercing. At any rate the likeness is better than any I have yet achieved. When I look at the reproductions of my old self-portraits I am amazed how badly I drew then. This portrait is *en face* and, on one side, the edge of the oval mirror gives a curved reflection of one-eighth of my face enlarged one-and-a-half times. Rather original, and not a hackneyed idea.' (J.N. Podkopaeva and A.N. Sveshnikova, *Somov*, 1979, p.349.) Somov made a replica of this portrait which he presented to a friend who also posed for him as a model, B.M. Snejkovsky, who presented it to the Russian Museum in Leningrad in 1968 (see Konstantin *Andreevich Somov. Katalog vistavki k 100-letiu so dnia rojdeniia hudojnika, 'Iskusstvo'*, 1971, p.92.)

Coll.: M.V. Braikevitch. **Exhib.:** Ashmolean, 1950 (No.38).

122 *Self-portrait with pince-nez*

Signed, dated, and inscribed: 'C. Somoff 1928 Grandvilliers'. Pastel. 262×171.

Coll.: M.V. Braikevitch. **Exhib.:** Ashmolean, 1950 (No.45).

123 *Christmas tree
(Christmas card for Mrs. Deterding)*

Signed: 'К. Сомовъ'. Pencil. 186 × 165.

On October 14 1929 Somov wrote to his sister: 'I am quite satisfied to-day because I worked a lot and I need only two hours to-morrow to finish the Christmas card which I mentioned before: "The End of the Christmas Party". It came out quite amusing, especially the old nanny who dozed off

with the child in her lap which is also asleep . . .'
(J.N. Podkopaeva and A.N. Sveshnikova, *Somov,* 1979, p.359).

Coll.: M.V. Braikevitch.

123

124

124 *Greedy monkey*

Signed and dated: 'C. Somof 29'. Bodycolours.
87 x 110.

A larger version of this composition made in
watercolours was commissioned from Somov by
the Russian poet Andrey Bely. 'I was commissioned
to paint a large version of the miniature "Greedy
Monkey" in the Braikevitch Collection. A monkey
has jumped on to a table laden with fruit and
flowers. In one hand it holds a banana which it is
eating; in the other, a broken plate. In the
background a maid, with her back to us, is drawing
the curtains.' (Russian Museum in Leningrad,
Somov Archive, fond 136). In the letter to his sister
of 26 March 1929 Somov writes: 'This week I
finished a small still-life. The subject is the
following: an interior of a room, a window, through
it an evening lemon-coloured sky. A maid en
silhouette with her back to the viewer is shutting
the dark crimson curtains. In the foreground an
oval table, on the table flowers in a vase, plates and
a large basket of various fruits. On the edge of the
table, crumpling the table-cloth sits a monkey. In
one paw she holds a banana, which she bites and
in the other a broken plate part of which lies on
the table-cloth. It is a very small miniature.'
(J.N. Podkopaeva and A.N. Sveshnikova, *Somov,*
1979, pp.351 and 584).

Coll.: M.V. Braikevitch. **Exhib.:** 'Somov', London,
1930 (No.20); Ashmolean, 1950 (No.48).

125 *Fireworks*

Signed and dated: 'C. Somof 1929'. Bodycolours
on black paper. 250 x 295.

On 4 August 1929 Somov writes to his sister:
'I have worked quite a lot and finished at last
"The Fireworks" which gave me so much trouble.
It came out quite well and I can at last give it to my
patron'. In an earlier letter (of 7 July 1929) the
painter reported of the difficulties he had with it:
'For some days I have been working on "Fireworks",
commissioned from me by my London patron. I
have spent many days just on the sky, as I couldn't
manage the effect of flying rockets and cascades of
sparkles.' The painter made four variants of this
gouache but Braikevitch chose the first one. (J.N.
Podkopaeva and A.N. Sveshnikova, *Somov,* 1979,

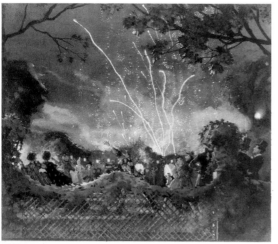

125

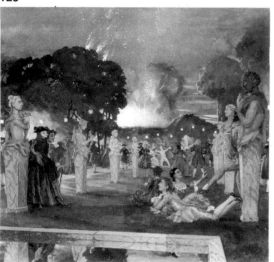

126

pp.357 and 585). In the 1950 Ashmolean
Exhibition Catalogue this drawing is called
"L'Arrivée des Sorcières", but Professor Savinov
pointed out that this was an error since Somov, in a
letter which relates to a picture of this name,
describes it as containing 'a devil, coffins, and other
macabre nonsense in fantastic light effects' – none
of which are present in the Ashmolean drawing. As
is often the case with Somov's later works, he made
use here of an earlier gouache, which was in the
collection of I.I. Troyanovsky (see S. Ernst, *Somov*,
1918, repr. facing p.42).

Coll.: M.V. Braikevitch. **Exhib.:** 'Somov', London,
1930 (No.46); 'Mir Iskusstva', London, 1950
(No.11); Ashmolean, 1950 (No.47).

126 *Fêtes aux environs de Venise*

Signed and dated: 'C. Somof 1930', and on verso:
'Constantin Somof Janvier 1930 Paris'.
Bodycolours on orange paper. 251 x 253.

This gouache was specially painted for the London
Exhibition of 1930.

Coll.: M.V. Braikevitch. **Exhib.:** 'Somov', London,
1930 (No.48); Ashmolean, 1950 (No.54).

127 *Bathers in the sun*

Signed and dated: 'C. Somov 1930'. Watercolours
and bodycolours. 161 x 125.

In a letter of 8 May 1930 Somov writes: 'I have
finished my last miniature for London. . . . It
represents bathers in a bright green sunny
landscape. In the foreground a young girl half-
length, not a beauty, but interesting and attractive,
and in the distance five nudes; one is lying with a
parasol and others are splashing in the water. It
looks very fresh.' (J.N. Podkapaeva and A.N.
Sveshnikova, *Somov*, 1979, p.367).

Coll.: M.V. Braikevitch. **Exhib.:** Ashmolean, 1950
(No.50).

128 *Girl in the sun*

Signed and dated: 'C. Somov 1930'. Watercolours
and bodycolours. 145 x 155.

Coll.: M.V. Braikevitch. **Exhib.:** 'Somov', London,
1930 (No.38); Ashmolean, 1950 (No.49).

129 *Versailles at night*

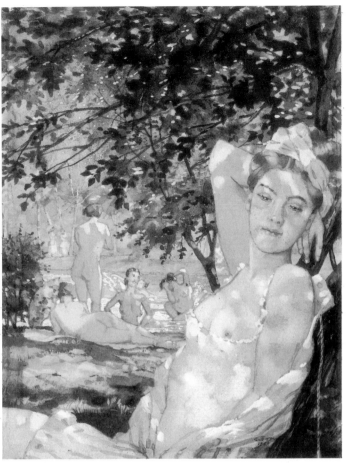

127

128

Signed, dated, and inscribed: 'C. Somov 1930 Paris'. Watercolours and bodycolours. 102x168.

Somov repeats here an earlier drawing in the collection of A.P. Ostroumova-Lebedeva in Leningrad (repr. in *Mir iskusstva,* 1903, Nos.1–2, p.24) but has added the girls on the bench dressed in eighteenth-century costume.

Coll.: M.V. Braikevitch. **Exhib.:** Ashmolean, 1950 (No.53).

130 *Couple dressed for a Venetian carnival*

Signed and dated: 'C. Somov. 30'. Bodycolours. 124x90 (oval).

On 9 May 1930 Somov writes: 'During these days I completed the last miniature of the task I set myself. It is a small oval gouache with two Venetian masks, man and woman against the background of a dark blue starry sky'. (J.N. Podkopaeva and A.N. Sveshnikova, *Somov,* 1979, p.366).

Coll.: M.V. Braikevitch. **Exhib.:** 'Somov', London, 1930 (No.44); Ashmolean, 1950 (No.51).

131 *At the dressing-table*

Signed and dated: 'C. Somov 30'. Watercolours and bodycolours. 65x50 (oval).

Coll.: M.V. Braikevitch. **Exhib.:** 'Somov', London, 1930 (No.29); Ashmolean, 1950 (No.60).

132 *Russian ballet*

Signed and dated: 'C. Somov. 1930'. Watercolours and bodycolours. 123x131.

Coll.: M.V. Braikevitch. **Exhib.:** 'Somov', London, 1930 (No.35); Ashmolean, 1950 (No.52). **Lit.:** J.N. Podkopaeva and A.N. Sveshnikova, *Somov,* 1979, Ill. No.71 (repr.).

133 *Study for a portrait of Miss Tatiana Braikevitch*

Signed, dated, and inscribed: 'C. Somoff, 1931, Paris'. Pastel. 354x253.

Also shown in colour on p.110.

Tatiana Mikhailovna Braikevitch (Soboleva by marriage) was born in 1906 and died in 1965. Somov described in some detail his work on her

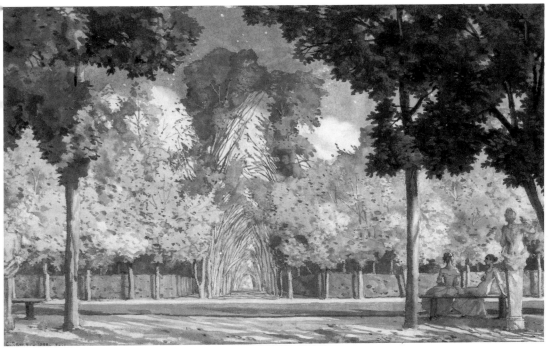

129

130

131

132

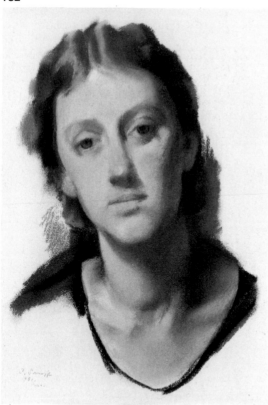

133

portrait in his letter of 7 April 1931: 'The main event in our life was the arrival of my admirer in Paris for whom I organised my private show. Meanwhile I had already started to paint a portrait of his daughter using my pastel study and a pencil drawing. I showed him all of this including the unfinished oil which is only just started. He approved of all of it and it cheered me up.' And in his letter of 3 June 1931 Somov quotes Braikevitch's high praise on receiving his daughter's portrait. The oil painting is now in the possession of Braikevitch's family.

Coll.: M.V. Braikevitch. **Exhib.:** Ashmolean, 1950 (No.56). **Lit.:** J.N. Podkopaeva and A.N. Sveshnikova, *Somov,* 1979, pp.381–382, 384.

134 *Landscape with shepherds and goats*

Signed and dated: 'C. Somov 1931'. Bodycolours. 135x185.

The painter describes the subject in a letter of 10 March 1931 as follows: 'I have painted a little fantasy on the subject of Daphnis and Chloe, only without them. A Greek landscape (imaginary) in the morning: there is sea in the distance with a barely visible horizon; the sky and the distant part of the sea are light lilac colour; the nearer the water the greener it becomes. Some peninsulas with buildings and fortresses can be seen. Shepherds and a flock of goats are in the foreground.' (J.N. Podkopaeva and A.N. Sveshnikova, *Somov,* 1979, p.380).

Coll.: M.V. Braikevitch. **Exhib.:** Ashmolean, 1950 (No.55).

135 *Daphnis and Chloe*

Signed and dated: 'C. Somov 1931'. Watercolours and bodycolours. 199x214.

On 11 January 1931 Somov wrote in his diary: 'Yesterday I finished my watercolour on which I have worked after the end of summer for 10 days from morning to evening. It came out very bright and sunny although not realistic. Bright blue sky, bright greens, the body of Daphnis dark red brown the body of Chloe gentle pink. There is eroticism in the bodies but it is discreet. The faces are not ugly. I wonder what my patron's impression will be.' (J.N. Podkopaeva and A.N. Sveshnikova, *Somov,* 1979, pp.376–377 and 588).

Coll.: M.V. Braikevitch. **Exhib.:** Ashmolean, 1950 (No.58).

134

135

136

137

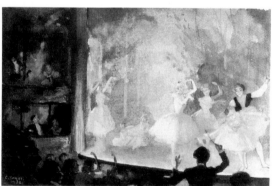

138

136 *Daphnis and Chloe*

Signed with a monogram: 'C.S.'. Pen and bistre wash with some zinc white. 145 x 105.

This was one of the illustrations to Long's *Daphnis and Chloe,* commissioned from Somov by Trianon publishers in Paris. The book came out in February 1931.

Coll.: M.V. Braikevitch. **Exhib.:** Ashmolean, 1950 (No.64).

137 *Still-life: an interior*

Signed and dated: 'C. Somoff 1931'. Pastel. 411 x 368.

In a letter to his sister of 2 April 1931 Somov writes: 'Pastel from nature, flowers, mirror and bric-à-brac on a chest of drawers . . . done in one *séance,* very sketchy, but came out rather well.' J.N. Podkopaeva and A.N. Sveshnikova, *Somov,* 1979, pp.376–377 and 588.

Coll.: M.V. Braikevitch. **Exhib.:** Ashmolean, 1950 (No.57).

138 *Russian ballet, Champs-Elysées:* Les Sylphides

Signed and dated: 'C. Somov 1932'. Watercolours, bodycolours, and indian ink on linen. 157 x 241.

Coll.: M.V. Braikevitch. **Exhib.:** Ashmolean, 1950 (No.59).

139 *Double portrait of Valeria Budanova-Usspenskaya (*previously catalogued as *Double Portrait of Tatiana Braikevitch as Tragedy and Comedy.)*

Signed, dated, and inscribed: 'C. Somov 1933. М. В. Брайкевичу. Сувениръ о его у меня пребываніи въ Парижъ.'. Pencil and light watercolour washes on orange-buff paper. Diameter (circular) 147.

On 19 September 1933 Somov wrote in his diary: 'During the last few days I have been working in the mornings on a head of a girl . . . Two views on one sheet. It did not come out as I wanted it (today is the last sitting) but it was very useful. I did it with the idea of painting a picture during the winter: something from Turghenev's Russian country-house life or the time of our youth. I wanted these two turns of the face to represent two twin sisters but

139

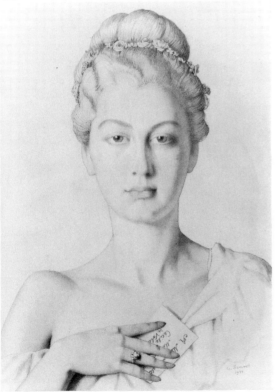

140

unfortunately it did not come out like that. One can't say that it is the same face. One is nearly *en face* and smiling, another serious and looking down.'

Coll.: M.V. Braikevitch. **Exhib.:** Ashmolean, 1950 (No.61). In the previous catalogues mistakenly called *Double Portrait of Tatiana Braikevitch as Tragedy and Comedy.*

140 *Imaginary portrait of Cecile de Volanges in Choderlos de Laclos's* Liasons Dangereuses

Signed and dated: 'C. Somov 1934'. Pencil, red chalk, and pale watercolour washes. 409 x 295.

This drawing was commissioned from Somov by Braikevitch to record an earlier one of 1917 which he had owned in Odessa and which is now in the Museum of Russian Art there. (see *Konstantin Somov. Katalog vistavki k 100 letiu . . .*, 1971, p.86). The Ashmolean drawing is a portrait of Alexandra Levchenko whose beauty was greatly admired by Somov. Somov mentions her several times in his diary of 1934. On 9 November she came for the first time as a model for Cecile de Volanges. On 12 November he writes: 'Shura Levchenko is an excellent model and perfectly silent. She is beautiful in her high hair-do with the crown of roses and she is beautiful altogether' and on 19 December 1934: 'In the morning I finished Cecile de Volanges'. (J.N. Podkopaeva and A.N. Sveshnikova, *Somov,* 1979, pp.423 and 594 repr. No.77).

Coll.: M.V. Braikevitch. **Exhib.:** Ashmolean, 1950 (No.63). **Lit.:** S. Ernst *Somov,* 1918, p.109; J.N. Podkopaeva and A.N. Sveshnikova, op. cit.

141 *Portrait of Mr M.V. Braikevitch*

Signed, dated, and inscribed 'Дорогому М. В. Брайкевичу на память объ июлъ 1934. К. Сомовъ.'. Black and red chalks and stump. 251 × 187.

On 10 July 1934 Somov wrote in his diary: 'Mikhail Vassilievich in spite of his age and difficult life retained an amazing idealism, sometimes bordering on naïveté. . . . He is full of affection for his friends. He asked me to draw a small pencil drawing of him à la Ingres and of course I agreed. It came out not like Ingres but like something much cheaper. The head is done in pencil and red chalk. The resemblance is not too great (we laughed that he looked more like Clémenceau) but he likes the modelling and technique. He thought it was a commission and was greatly surprised that I

inscribed it: ''To dear Mikhail Vassilievich in memory of July 34''. He protested and protested but agreed.' (J.N. Podkopaeva and A.N. Sveshnikova, *Somov,* 1979, pp.419–420 and 594.)

Coll.: M.V. Braikevitch. **Exhib.:** Ashmolean, 1950 (No.62).

142 *A copy of the so-called* Portrait of Simonetta Vespucci

Oil on canvas. 550x460.

Copy of the painting (panel, 57x42 cm) in the Musée Condé, Chantilly, attributed to Pollaiuolo in the catalogue of 1899 but now generally accepted as by Piero di Cosimo (Bacci, *Piero di Cosimo,* 1966, p.67, No.4, repr.). Unfortunately no letters by Somov have survived after January 1936 and this important work is not therefore recorded in his archive.

Coll.: M.V. Braikevitch.

141

142

Sergey Vasil'evich Tchehonine (Chekhonin)

Born in Valdaika, 2 February 1878; died in Paris, 23 February 1936. Studied at the School of the Society for the Encouragement of the Arts in St. Petersburg and in Princess Tenisheva's studio under Repin. In 1904 he worked in Abramzevo's studio with Vrubel and Golovin. A fine watercolourist and book illustrator. Tchechonine won an outstanding reputation for his constructivist designs for porcelain (he took the Gold Medal at the International Exhibition of Industrial Art in Paris in 1925). After emigrating to Paris he turned to stage design work.

143 *The artist's wife in bed*

Signed, dated, and inscribed: 'Сергѣй Чехонинъ 1916 г. Москва.'. Watercolours over pencil indications. 125 × 175.

Coll.: Dr. Tatiana Gourlande.

144 *A milkmaid*

Signed: 'S. Tchekhonine'. Pencil and watercolours. 313×239.

Also shown in colour on p.100.

A design for one of the characters in Popoff's *Porcelains,* a short ballet presented by Nikita Baliev's Théâtre de la Chauve-Souris in Paris, 1927.

Purchased in 1970.

143

144

Pavel Fedorovich Tchelitchev (Chelishchev)

Born Moscow 21 September 1898; died in Rome, 31 July 1957. In 1918 his family moved to Kiev where he attended the Academy of the Fine Arts under Alexandra Exter. He emigrated in 1920, first to Istanbul, then to Sofia and Berlin, and finally settled in the U.S.A. He worked mainly as a stage designer.

145

145 *Still-life: three pears on a plate*

Signed and dated: 'P. Tchelitchew, 1927'. Watercolours. 250 x 340.

Coll.: Thomas Balston. Bequeathed by him in 1968.

146 *Study of a seated woman*

Signed and dated: 'P. Tchelitchew 31'. Brush and brown ink. 255 x 210.

Coll.: Thomas Balston. Bequeathed by him in 1968.

146

Aleksandr Evgen'evich Yakovlev *see* nos.53–55

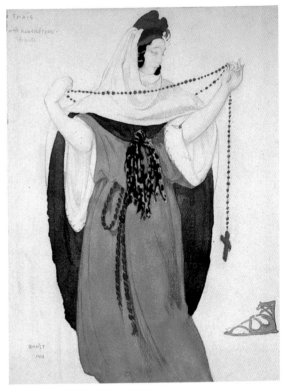

5

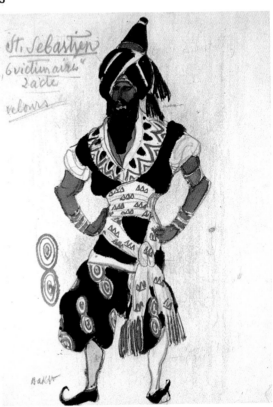

7

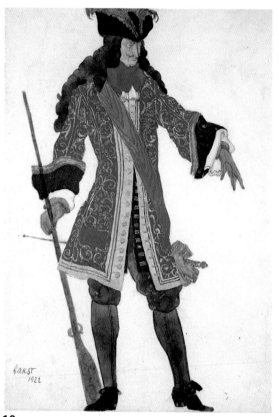

13

45

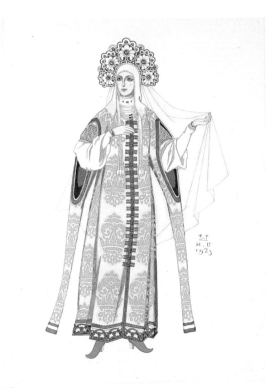

32

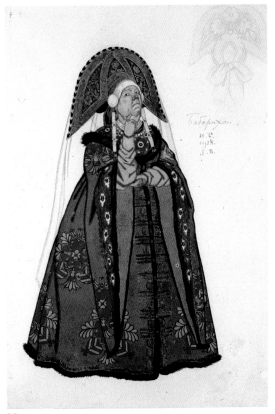

33

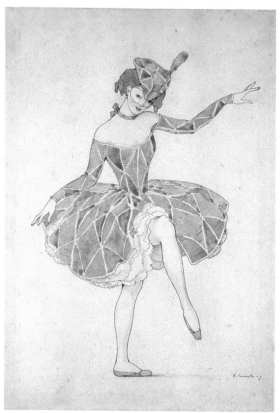

111

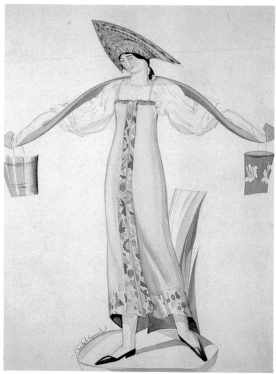

144

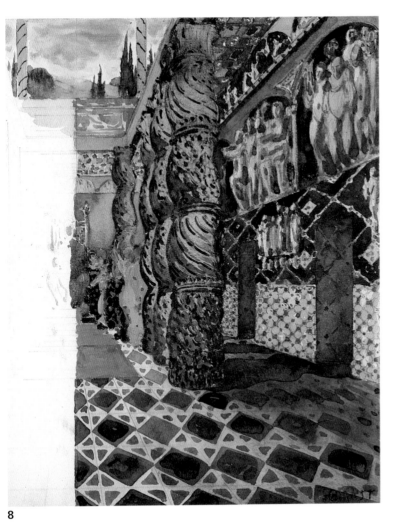

8

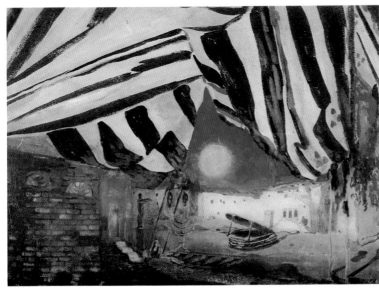

11

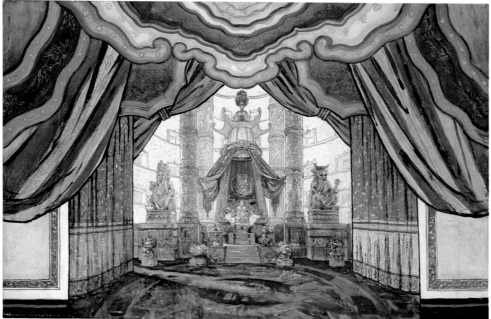

21

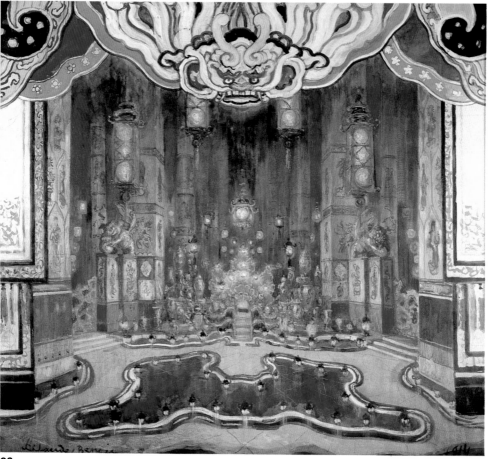

22

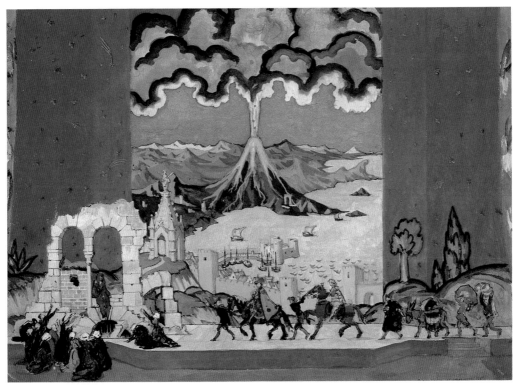

25

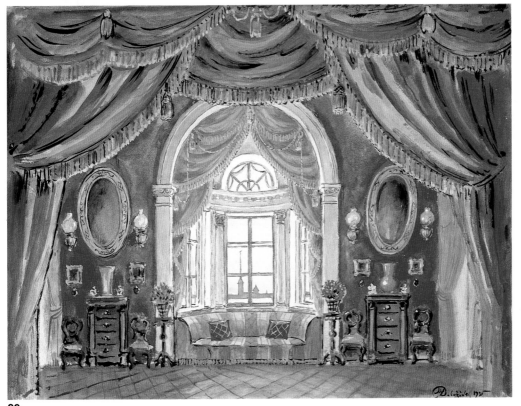

39

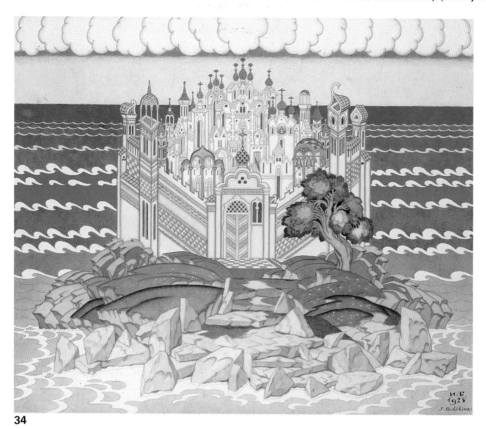

34

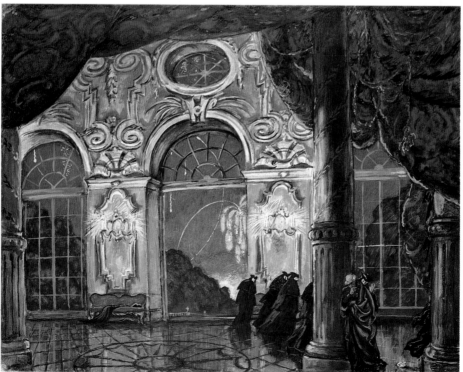

38

97

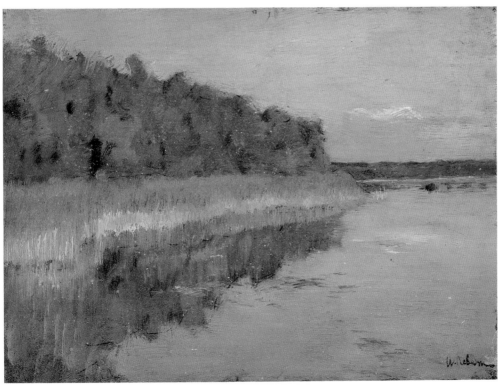

72

41

47

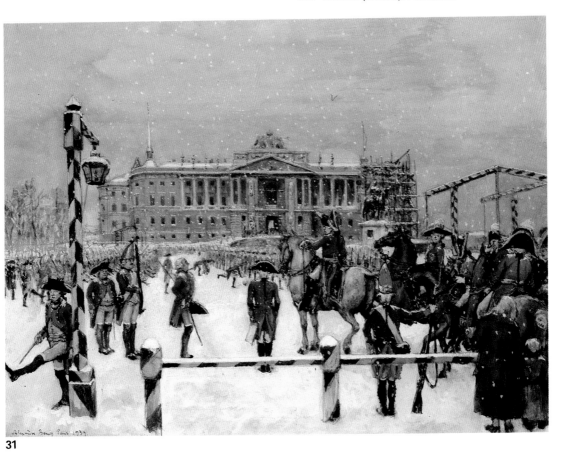

31

82

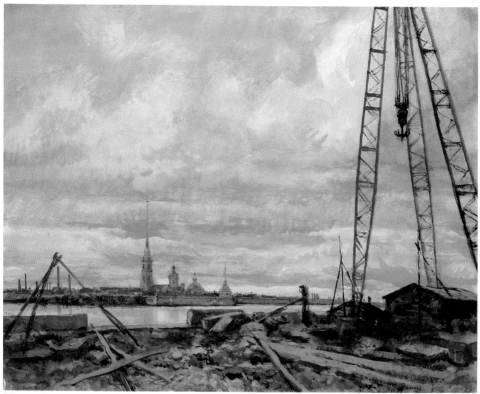

23

98

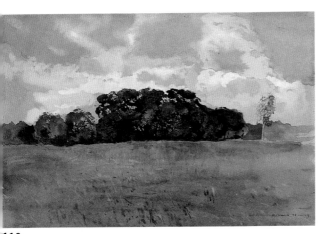

110

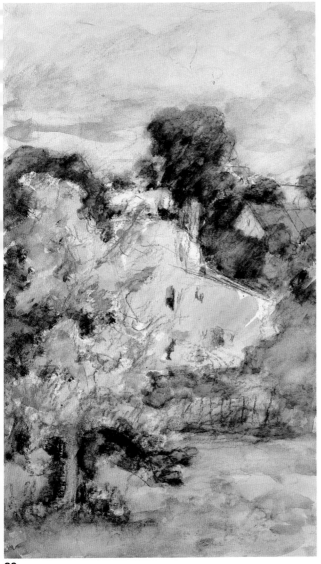

121

133

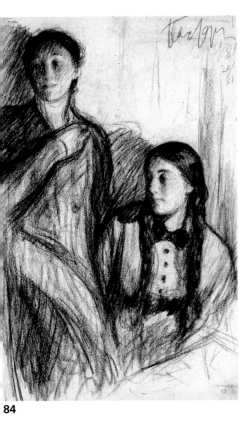

84

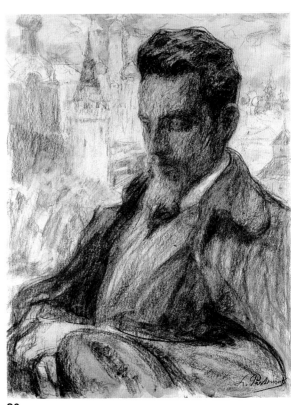

86

112

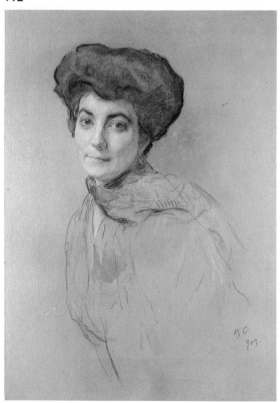

107